IMAGES
of America

AUGUSTA
AND AIKEN
IN GOLF'S GOLDEN AGE

Rockyview General Hospital

Invitational

Great Golfing!
Stan Lynde

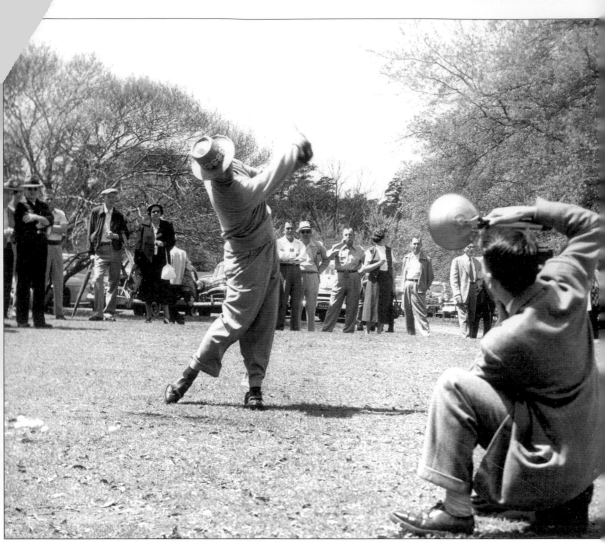

GOT IT! Sam Snead's swing is captured on film as the golf great loosens up on the practice tee, believed to be at Forest Hills in Augusta. (Photo by Robert Wilkinson; courtesy Augusta Museum of History.)

IMAGES *of America*

AUGUSTA
AND AIKEN
IN GOLF'S GOLDEN AGE

Stan Byrdy
with a foreword by Augusta Mayor Bob Young

ARCADIA

Published by Arcadia Publishing,
an imprint of Tempus Publishing, Inc.
2 Cumberland Street
Charleston, SC 29401

Printed in Great Britain.

Library of Congress Catalog Card Number: 2002112072

For all general information contact Arcadia Publishing at:
Telephone 843-853-2070
Fax 843-853-0044
E-Mail sales@arcadiapublishing.com

For customer service and orders:
Toll-Free 1-888-313-2665

Visit us on the internet at http://www.arcadiapublishing.com

To Donna, with all my love

CONTENTS

ACKNOWLEDGMENTS

Katie White; Arcadia Publishing
Ward Clayton, Director of Editorial Services; PGA Tour
Phil Lane, Mary Jones, and Pete Michenfelder; WJBF-TV
Mark Childress, Rick Thomas, and A. Barrett Wells
Frank Christian; Christian Studios, Augusta
Todd Hollister Lista; Lista's Studio of Photography, Inc., Aiken
Clyde Wells; Special Collection, Augusta Municipal Golf Course
William S. Morris III
Robert W. Knowles Jr.
Stewart Hull
Nell Callahan
Douglas R. Duncan Jr.
Mayor Bob Young
Cobbs Nixon
James Whitmore
Joseph M. Lee III; Special Collection, Postcards
Bill Baab; Special Collection, Memorabilia
Neil Ghingold; Special Collection, Antiques
Ross Snellings; Special Collection, Forest Hills
Milledge G. Murray; Special Collection, Baseball
Glen Greenspan; Augusta National Golf Club
Red Price, Robby Watson, Scott Allen, and Carlton "Beanie" Morris; Forest Hills Golf Club
Tom and Kathy Moore and Joe Armstrong; Palmetto Golf Club
Eileen Stulb, Henry Marburger, and Jane Floyd; Augusta Country Club
Jim McNair Jr., Brent McGee, and Todd Bourke; Aiken Golf Club
Guy Reid, Hank Leffler, Lonnie Henderson, Butch Lord, and Peggy Owens; Augusta Municipal
 Golf Course
Blaine Patin and Mike Swayne; The First Tee of Augusta
Bert Harbin and Bill Bottomley; The Women's Titleholders Golf Association
Carolyn W. Miles and Carolyn Tyler; Aiken County Historical Museum
Erick Montgomery; Historic Augusta, Inc.
Scott W. Loehr and Gordon A. Blaker; Augusta Museum of History
Vicki Greene; Augusta-Richmond County Historical Society
Bill Wells, John O'Shea, Jeff Heck, David White, and Rick Sulzycki; Reese Library, Augusta
 State University
Jeanne McDaniel and Robert Croom; Heritage Council of North Augusta
Dr. Joe Holt; Pine Heights, North Augusta
Beech Island Agricultural Club
Charles W. Strawser and Diane King; Georgia Golf Hall of Fame
Don Grantham and Grady Smith; Augusta Golf Association
Staff, Wolf Camera, Furys Ferry Road, Martinez, Georgia

FOREWORD

It's getting to be a rather common occurrence for the mayor of Augusta. One of the more popular questions I get is, "Can you arrange for me to play the Augusta National Golf Club course?" People used to ask for tickets to the Masters Tournament. Now, they want to tee it up where Jack and Tiger rule.

Most people don't understand that the most famous piece of real estate in Augusta is a private club. Members and their guests only. And, no, the mayor is not a member.

This brings to mind a recent trip to Japan, where talk wandered from business to golf. (Everyone in Japan, I think, plays golf.) These men thought playing Augusta National was as simple as showing up at the gate on Washington Road with your clubs.

That gate is probably the most popular tourist stop in the city. Everyday you'll see people standing along the busy commercial strip, posing with the sign, guard shack, gate, and Magnolia Lane in the background. Look, but do not enter.

Such is the mystique of golf in Augusta. Golf and the Godfather of Soul, James Brown. Augusta is known for both, and quite appropriately. We host the most important sporting event in the world and are home to the most important music legend still alive today. Golf balls and clubs; clef notes and splits.

Golf has been an interest of mine for nearly half a century. From my earliest memories I can recall swinging a club, more to beat the ground than with the result of hitting any object I had strategically positioned in front of me. As an adult, I play off and on with results similar to those from my childhood.

The great thing about golf is that anyone can play, and it doesn't really matter how well you play if the purpose is fellowship and fun. Somewhere, sometime during your round, you will hit a golf shot that begs to be described over and over again. Indeed, whether you go around a course in par or triple digits, the law of averages is in your favor to accomplish at least one moment that bears repeating to everyone who will listen at work the next day.

But, let your friends know you are from Augusta, Georgia, and the rules change. Augusta is not just another city for golf. It is a golf mecca. Everyone is born with a natural grip, and a set of clubs is presented at every baby shower. You're driven home from the hospital in a golf cart. Or, so the world believes.

There's no time for serious work in Augusta. No, not with all the golf that has to be played. Everyone in Augusta is into golf, just as golf is into Augusta. If only life in Georgia's "Garden City" were so simple.

One tournament, one course, one week out of 52 gives our city this incredible reputation and recognition. Being the host city for the Masters raises expectations.

Yes, a lot of people in Augusta do play golf, but not at Augusta National. We have many other beautiful public and private courses. The mystique of the Augusta National Golf Club is not lost on the locals.

But it hasn't always been this way, as Stan Byrdy shows us in a marvelous journey that begins with the arrival of golf in Augusta more than 100 years ago. Well, actually, it arrived in nearby Aiken, South Carolina. I suspect those early golfers were the object of much of the same curiosity people have about Augusta National members today.

It didn't take the Masters to make Augusta a golf destination. The tourists discovered Augusta's temperate winter climate at the turn of century. The city became immensely popular because of the resort hotels with their own courses and access to the Augusta Country Club for special visitors. In the meantime, people in Aiken were finding horses more fascinating than golf.

When Bobby Jones and Clifford Roberts took over a nursery to build their dream course, the face of golf in Augusta changed forever. It also changed a bit elsewhere in this big world.

Masters is a common tournament name in foreign lands. (It's a registered trademark here.) A few years ago I visited the Taiwan Masters, where the highlight was free noodles and free beer.

This year at the Keya Club in Fukuoka, Japan, I presented the winner's trophy to Nobumitsu Yuhara, who had just won the Hisamitsu-KBC Augusta Golf Tournament, which, I have learned, has been around for 30 years!

In the 1950s Augusta National member and U.S. President Dwight David Eisenhower introduced golf to the masses. Coupled with fan-favorite Arnold Palmer's win at the Masters and success on the tour, golf had arrived.

It's a history filled with the tradition of the men of the Masters and ladies of the Titleholders and Asahi Royokuken International Championship. A history preserved in the Georgia Golf Hall of Fame and Gardens. A history written by Augusta-bred professionals like Larry Mize, Franklin Langham, Charles Howell III, and Mitzi Edge. A history nurtured in Saturday morning classes for youngsters at First Tee. A history that recognizes incredible regional amateur talent in the Regions Cup series.

Augusta is indeed a golf destination, from the lush, rolling woods of Jones Creek to the flat, marshy layout of the River Course. The city government even owns a course affectionately called "The Cabbage Patch."

What we are today is a reflection of the path we've traveled to get here. History and tradition cast a long shadow that has been captured exceptionally by Mr. Byrdy. His personal familiarity with Augusta and golf come from years of covering the sport for the local ABC affiliate, WJBF-TV. I suspect there is no living person who has covered as much golf and other sports for television in this city than Stan Byrdy.

Golf and Augusta. It doesn't get any better than this.

Mayor Bob Young
City of Augusta

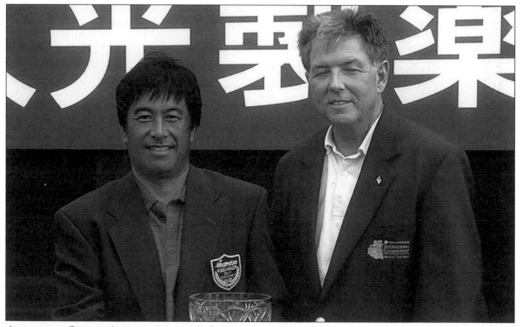

AUGUSTA OPEN. Augusta Mayor Bob Young presents Nobumitsu Yuhara with the winner's trophy in the Hisamitsu-KBC Augusta Golf Tournament. The 30-year-old event was contested in August 2002 at Keya Club in Fukota, Japan.

One

SUMMIT ON THE
SAND HILLS

While golf has been a major part of the social scene in Augusta for well over 100 years, sand hills have apparently been here a bit longer. As history records it, sand dunes crested an ancient seashore to form a large ridge dividing the Piedmont and Coastal Plain regions. Left behind was a hill that would one day overlook the city of Augusta in a section of town aptly named the Sand Hills. When the Bon Air Golf Club was laid out in 1897, Sand Hills met sand greens, and the fate of Augusta was changed forever.

By the time Bobby Jones was born on St. Patrick's Day, 1902, Augusta was well established as a winter haven for the nation's golf elite. Two decades later, Jones, too, found Augusta the ideal site to champion his game; its winters were milder than those in Atlanta, 135 miles to the west, and it had the natural setting on which to build his dream. Soon enough, Jones would capture the Southeastern Open at Augusta Country Club and Forrest Hills, and later that summer of 1930, the Grand Slam. As Jones turned his thoughts to even loftier goals, a new chapter in Augusta's long and storied golf history was about to be written.

From the quaint cottages, grand hotels, and golf courses of the early 1900s to Bobby Jones's dream and Larry Mize's sand wedge, Augusta enters a new century with a renewed vision for golf. The Golf and Gardens, Georgia Golf Hall of Fame, First Tee, and a new breed of golf champions intent on raising the bar to new heights will surely be partners in molding this next step in Augusta's golf legacy.

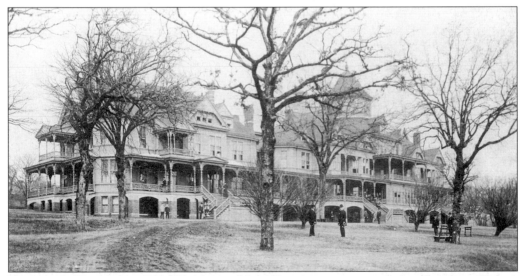

HARISON'S HOUSE, C. 1895. The elegant Hotel Bon Air is seen in a photo taken from Walton Way. Country Club of Augusta president from 1900 to 1920, Dr. William Henry Harison and family were major stockholders in the Bon Air and helped found Augusta's first golf course at the Bon Air Golf Club. Harrison and head golf professional David Ogilvie later designed the Country Club of Augusta's original Hill Course. (Courtesy Augusta Museum of History.)

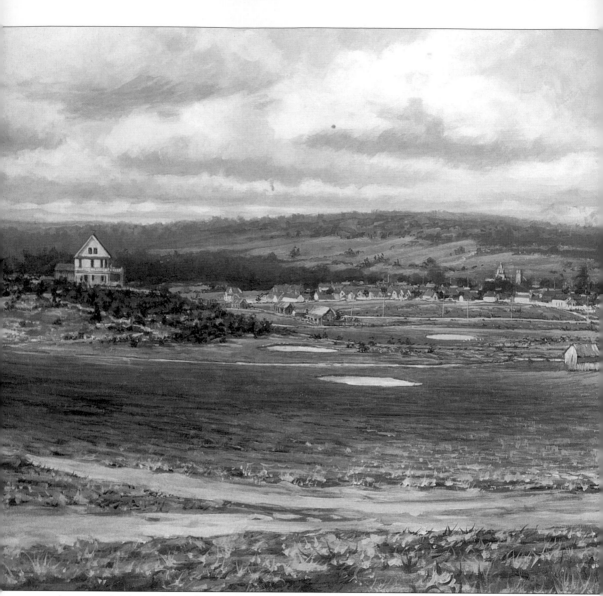

AUGUSTA'S FIRST GOLF COURSE, C. 1897. The pictures used in creating this lithograph were taken by the photographer Montell from the porch of the Hotel Bon Air in December 1897. Over a century later, the pictures were digitally connected, providing a panoramic view of the Bon Air Golf Course and Savannah River valley. Photographer Frank Christian commissioned the artwork as a fund-raiser for the Augusta State University women's golf team. The lack of trees and shrubbery in the lithograph provides a stark contrast to the area overlooking downtown Augusta today. The road in the foreground is Battle Row and the home on the left is believed to still exist on Telfair near Milledge Road.

Located on land adjacent to the Hotel Bon Air, Augusta's first golf course was constructed in 1897 for hotel guests and winter residents of Summerville. The Bon Air Golf Club consisted of nine holes and a clubhouse, which played a major role in changing the fate of Augusta's future. The structure in the middle of the picture behind the sand green is the golf clubhouse.

For the season beginning in January 1898, according to a report in *The Augusta Chronicle*, a professional golfer, Mr. Fitzjohns, a recent arrival from Scotland, gave lessons, "as each

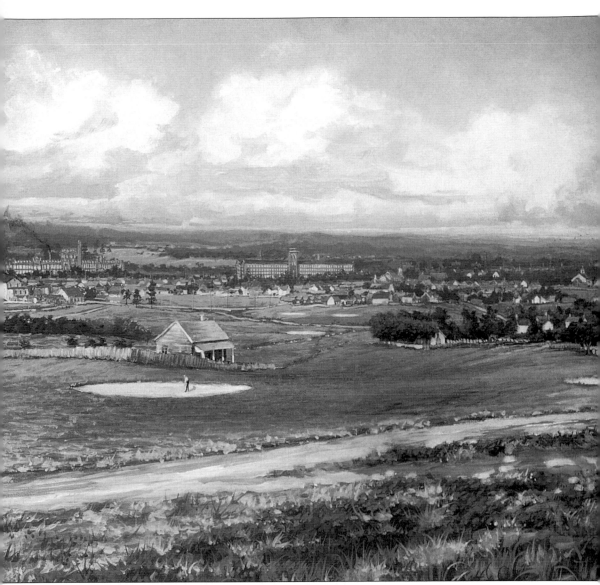

day brings new devotees to the sport." (Fellow countryman David Ogilvie arrived on the scene as the club's first head professional two years later.) The report concludes, "As yet, few Augustans have displayed any interest in this game, though it is thought the rage for this sport will be felt intensely here as in the northern cities."

An article in the January 30, 1898 edition of *The Augusta Chronicle* reports that horseback riding at the Bon Air is in decline and that "bicycle riding excites little or no interest; the fad with those who rode only for pleasure died the death of all such passing novelties." The article goes on to surmise that the new sport of golf may be the reason for these developments, as "golf requires all the energy that can be devoted to outdoor sport." The report continues that golf has been lightly received by Augustans, "In fact, the only reason the game is known at all is due to northern enthusiasts. To them a season without golf is what a barbeque without meat is to a Southerner." (Courtesy Frank Christian Collection.)

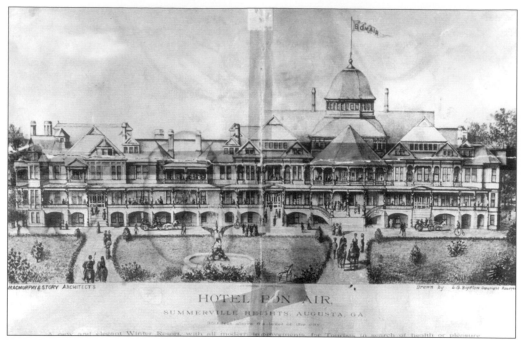

BON AIR ARCHITECTURE, C. 1888. This architect's drawing of the Hotel Bon Air was utilized as an advertisement for the grand opening of the winter resort on New Years Day, 1889. Constructed 350 feet above the level of the city of Augusta, the original Bon Air burned in 1921 and was later rebuilt. It serves today as a center for senior citizens. (Courtesy Augusta Museum of History.)

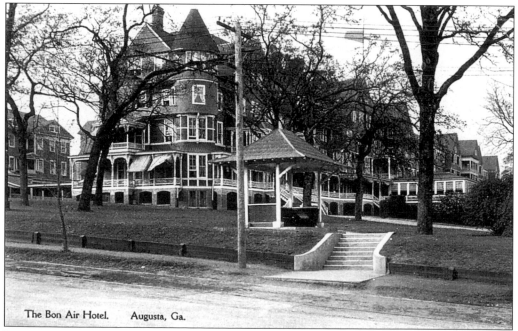

The Bon Air Hotel. Augusta, Ga.

BON AIR RARE, C. 1915. A view of the original Bon Air from Walton Way features the elegant detail of the wooden structure. Note the hotel annex to the left. (Courtesy Joseph M. Lee III.)

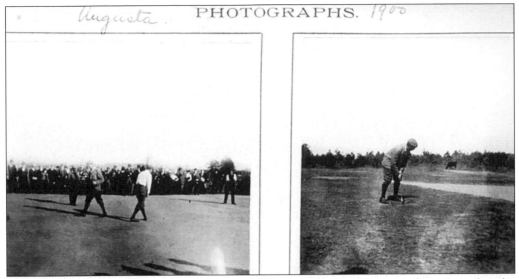

VARDON'S VISIT, C. 1900. Harry Vardon was the reigning British Open champion when he played an exhibition at the Bon Air Golf Club in 1900 and is shown here on the second and third greens. Note the cow grazing in the background of the photo on the right. The course was expanded to 18 holes that year by adding a 10th hole to the existing course on the east side of Milledge Road and another eight holes on the west side of the road, and also underwent a name change to the Country Club of Augusta. The PGA of America presents the Vardon trophy annually to the touring professional with the season's lowest scoring average. (Courtesy Augusta Country Club.)

HOTEL BON AIR ENVELOPE, C. 1907. The Hotel Bon Air is depicted as a winter golf resort on this envelope mailed from Augusta in 1907. Note the postage for mailing a letter was 2¢, which was twice the cost of sending a postcard. (Courtesy Bill Baab Collection.)

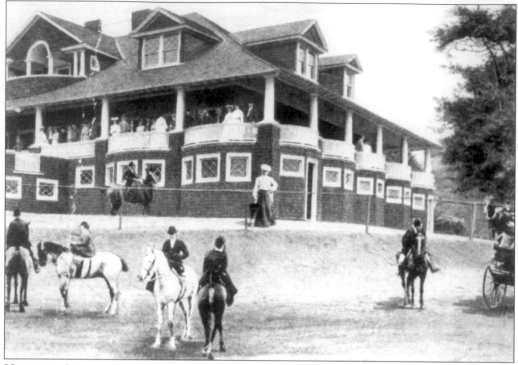

HORSING AROUND, C. 1905. Riding horses was a popular winter sporting activity at the Augusta Country Club, where bridle paths were laid out around the golf courses. (Courtesy Augusta-Richmond County Historical Society, Reese Library, Augusta State University.)

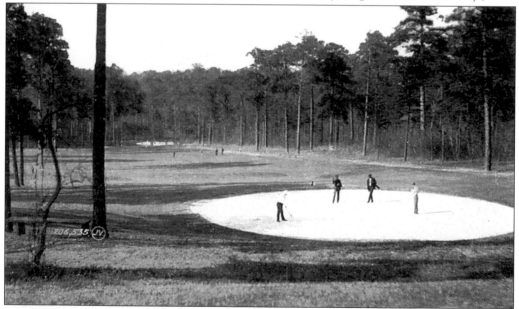

SAND SURFACE. Seth Raynor converted the Lake Course to grass greens in 1926 as Donald Ross installed the new playing surfaces on his design at Forrest Hills. Ross was retained to convert greens at the Augusta Country Club's Hill Course the following year. (Courtesy Joseph M. Lee III.)

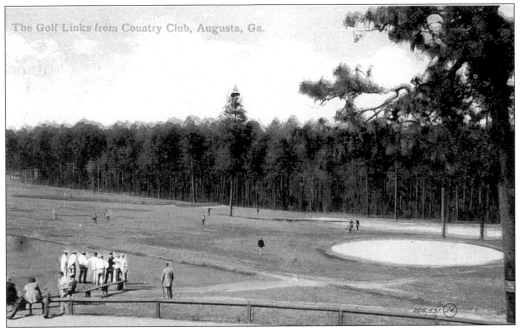

AWAITING THE FINISH, C. 1912. Another view of a sand green at Augusta Country Club shows golfers waiting for others to finish a round. (Courtesy Joseph M. Lee III.)

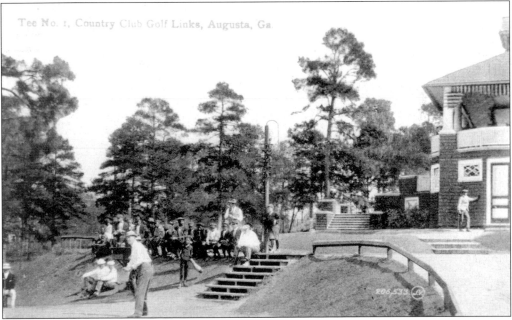

THE FIRST TEE, C. 1912. Shown here is the first tee of the Country Club of Augusta's Hill Course. It was a 340-yard, par-4 hole when it debuted in 1911. Today the whole plays 373 yards from the white tees. (Courtesy Joe Lee Collection, Augusta-Richmond County Historical Society, Reese Library, Augusta State University.)

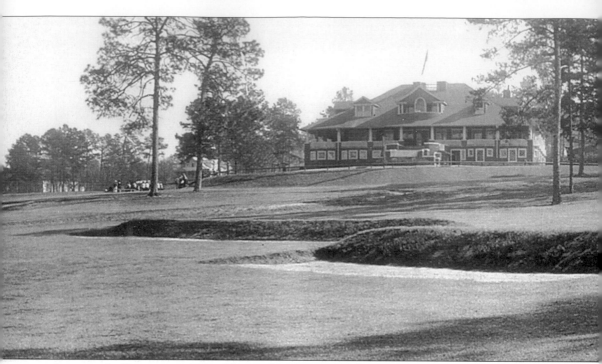

AUGUSTA'S FINEST, C. 1909. This early 1900s view shows the Country Club of Augusta's Lake Course and Clubhouse. The Lake Course measured 5,873 yards in 1905 and 10 years later played 40 yards shorter, an anomaly by today's standards. During the Depression, lack of funding for two courses forced the closure of the Lake Course in 1937. Note the

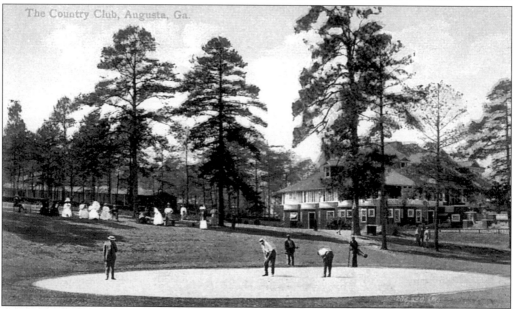

The Country Club, Augusta, Ga.

SAND CIRCLE, C. 1910. This view of the number 18 sand surface was taken about the same time as the large photo above. Note the group of women watching play in this picture. The knoll they are seated on is located in the upper left of the large photo above. (Courtesy Joseph M. Lee III.)

well-manicured course and grounds of nearly a century ago and the deep bunkers guarding the fairway leading to a hidden sand surface. Visitors could play the Lake Course for green fees of $5 per month, $1.50 per week, or 50¢ per day. (Courtesy Henry Marburger, Augusta Country Club.)

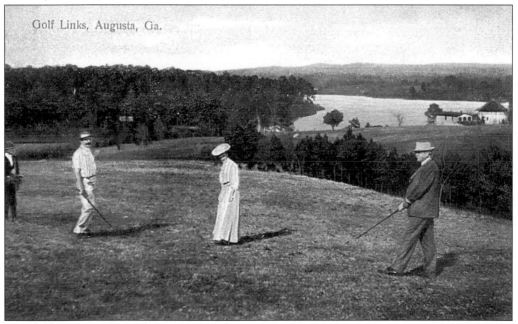

Golf Links, Augusta, Ga.

TEE IT HIGH, C. 1905. This postcard portrays the Lake Course's 12th tee. Country Club Hills subdivision is built on and around property that once comprised the layout. The photo was taken at the end of present-day Morningside Drive. (Courtesy Joseph M. Lee III.)

TAFT WINTER HOME, C. 1908. Terrett Cottage near the Hotel Bon Air was the winter home of President William Howard Taft. Located at the corner of Milledge and Cumming Roads, the structure was torn down when Cumming Road was extended east. During the winter of 1909 a grand banquet was held in honor of then President-elect Taft at the Hampton Terrace Hotel. Among those in attendance was John D. Rockefeller. According to a report in *The Augusta Chronicle* on Friday, January 21, 1909, Taft greeted him with "How are you, Mr. Rockefeller," then gushed with pride, "I got around the golf links in 88 today." The statement was in reference to Taft's personal best round of golf at the Country Club of Augusta earlier that day. (Courtesy Joe Lee Collection, Augusta-Richmond County Historical Society, Reese Library, Augusta State University.)

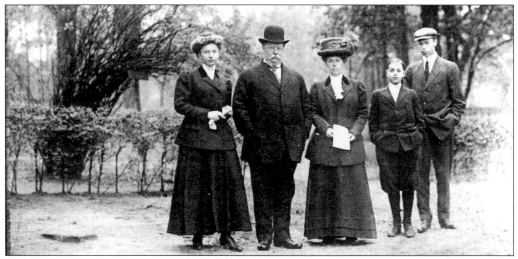

CHRISTMAS HOLIDAYS, C. 1908. President-elect William Howard Taft and his family are photographed in Augusta during Christmas, 1908. Pictured from left to right are wife Helen Herron Taft, Taft, daughter Helen Herron Taft, and sons Charles Phelps Taft and Robert Alphonso Taft. His inauguration not scheduled until March 1909, Taft played golf daily at the Augusta Country Club and picked his cabinet members while vacationing in Augusta for more than a month that winter. (Courtesy Glover R. Bailie Jr. Collection, Augusta-Richmond County Historical Society, Reese Library, Augusta State University.)

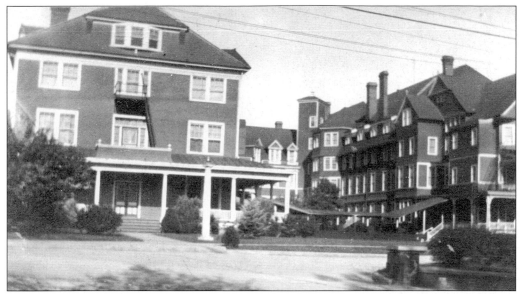

HOTEL BON AIR, C. 1914. This picture of the Bon Air facing north from Walton Way features the hotel's annex on the left. This entrance at the top of "the Hill" remains in use today. Note the exquisite workmanship of the original wooden hotel, which burned to the ground during the winter season of 1921. (Courtesy Augusta Museum of History.)

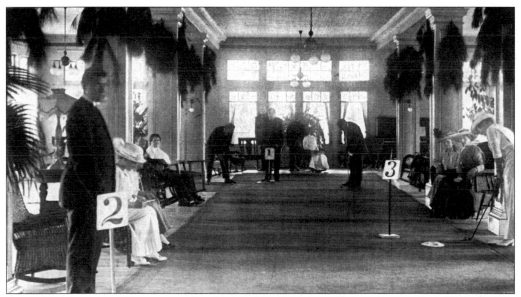

LOBBY-ING, C. 1916. During evening hours and when the weather was not favorable, putting contests were organized in the lobby of the Partridge Inn, where team matches grew to become a popular feature. Guests of the Partridge Inn retained golf-playing privileges at the Country Club of Augusta's nearby Lake and Hill Courses. A shuttle maintained during the winter season transported golfers to and from the clubhouse. (Courtesy Augusta Museum of History.)

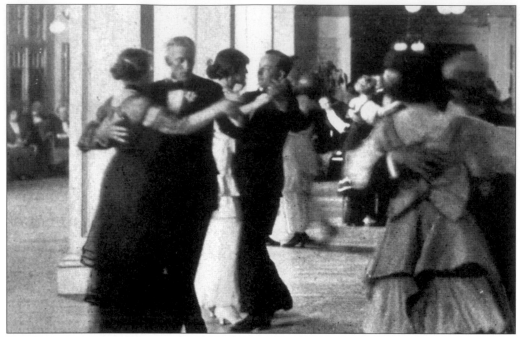

INN SYNC, C. 1916. Glass enclosed on three sides, the Partridge Inn's lobby and sun parlor made for magnificent ballroom dancing. With top-notch orchestras providing the music, dances at Augusta-Aiken's winter resorts were a feature attraction for guests throughout the season. The nearby Hampton Terrace in North Augusta also featured a glass-enclosed piazza that could be utilized for dances. From the sun parlor, guests had striking views of the Georgia and South Carolina forest, hills, and river, as well as views of the Country Club of Augusta's

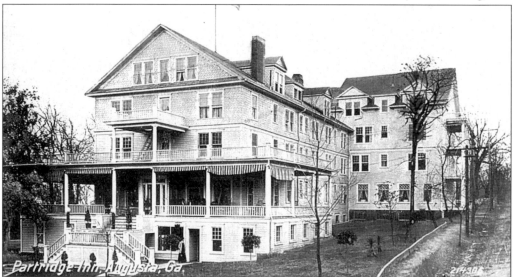

PARTRIDGE PLACE, C. 1910. This residence purchased by Morris Partridge in the late 1890s was transformed into the Partridge Inn. Officially opened for business in 1908, the original Partridge Inn was a small hotel and family resort, with designs on becoming a grand hotel. The Inn added 20 rooms in 1909 and announced the addition of 50 more rooms the following year. (Courtesy Milledge G. Murray Collection.)

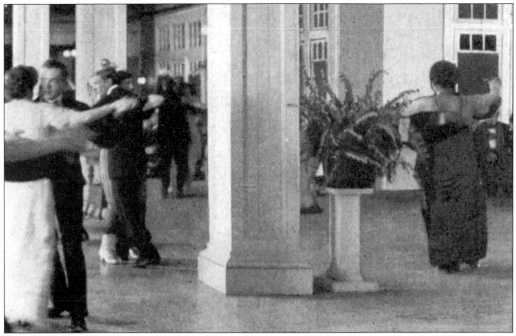

Lake and Hill golf courses, and Camp Hancock, part of which was transformed into the Forrest Hills-Ricker hotel and golf resort in 1926. The Partridge Inn is located across the street from the Hotel Bon Air, on what was once the most prominent corner in Augusta's winter resort area. The inn is built on property originally owned by George Walton, signer of the Declaration of Independence. (Courtesy Augusta Museum of History.)

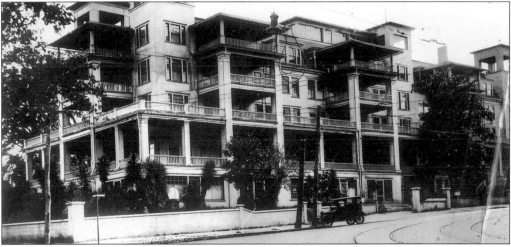

PARTRIDGE INN, C. 1925. During the 1920s, the Partridge Inn continued its expansion plans. The framework of the original structure lies hidden in the walls of this mid-1920s view. Note the trolley tracks on Walton Way in front of the inn. A post office, telegraph office, flower shop, bookstore, barbershop, hairdressing parlor, and the only drug store in the resort section distinguished the Partridge Inn as a central gathering spot for the vacationing Winter Colony. The well-appointed inn also contained an electric elevator from the ground floor to the sun parlor on the roof. The dining area of the Partridge Inn was described as bright and airy, and could accommodate over 300 guests. (Courtesy Frank Christian Collection.)

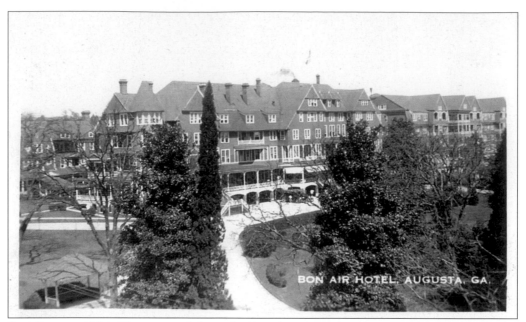

BON FIRE, C. 1921. This postcard shows the Bon Air prior to its destruction by fire on February 4, 1921; it was taken from the Partridge Inn on Walton Way. The postmark on the reverse of this card is dated January 10, 1921, less than a month from the blaze that destroyed the elegant wooden structure.

"Bon Air Hotel Is Destroyed By Fire" roared headlines across the front page of the afternoon edition of *The Augusta Chronicle* on Friday, February 4, 1921. According to the paper's reports, day clerk A.E. Taylor is credited with saving the lives of 260 sleeping guests, all of whom escaped unharmed. "Awakened at 2:30 a.m. by a chambermaid shrieking 'Fire', Taylor jumped from his bed and ran door to door through the corridors with the news." Within 15 minutes, "guests were pouring from all exits" and within an hour, flames that began in a dining area now engulfed an entire wing. By 4 a.m., "trunks, bundles, hatboxes, golf clubs, and a thousand odds and ends littered the lawn."

The Chronicle continued, "The fire raged, throwing up such a brilliant flame that the entire section of Summerville was as light as day. The walls of the hotel fell one by one. The heat for hundreds of yards became terrific. Frightened, excited guests in the Partridge Inn crowded the windows and balconies, or poured out into the streets. For several hours the scene was one of utter confusion, the firemen battling steadily, the police guards keeping the crowds back, the ambulances arriving to see if anyone was injured, and the explosions of gasoline from the garages, bringing to mind the Hampton Terrace fire, which occurred under the same conditions, at the same hour of the morning." As was the case with the blaze at the Hampton Terrace five years earlier, firemen got several streams of water on the fire, but low water pressure to the high altitude, wooden structure hampered efforts. The Hotel Bon Air carried some $500,000 in insurance on the building, with losses placed at approximately $1.5 million. The Bon Air was rebuilt and the landmark "on the Hill" serves the Augusta community today as a center for senior citizens. (Courtesy Joseph M. Lee III.)

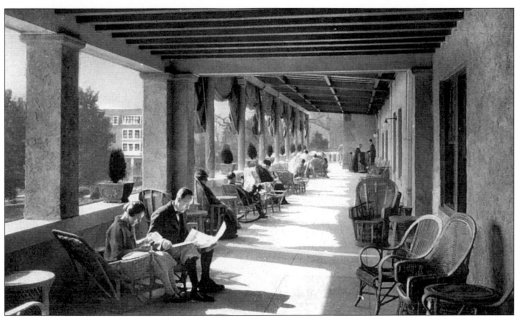

BALCONY BON AIR, C. 1933. This spacious balcony allows for an abundance of sunshine. Note the Partridge Inn in the background. When the Augusta National Golf Club hosted its official course opening in January 1933, charter members lodged at the Hotel Bon Air during their three-night stay. (Courtesy Joseph M. Lee III.)

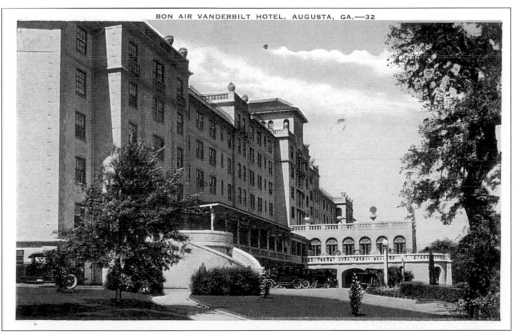

BON VIVANT, C. 1935. This side view shows the elegant Bon Air, which serves today as a home for senior citizens. Rebuilt of concrete after a fire destroyed the original wood structure in 1921, the new Bon Air Vanderbilt was not quite as large, but every bit as elegant as the facility that burned. (Courtesy Joseph M. Lee III.)

SAND-BAGGING, C. 1922. Prior to the inception of grass greens, putting surfaces were made of hard packed earth with sand sprinkled neatly on top. During the mid-to-late 1920s, the conversion from sand to grass greens marked a major change in how the game was played. Prior to that time, golfers laid up on all holes, and according to South Carolina Golf Hall of Fame member Bobby Knowles of Aiken, hitting the green on a fly would cause the ball to skip away, much like landing on a concrete sidewalk. (Courtesy Scott Nixon Collection, Augusta Museum of History.)

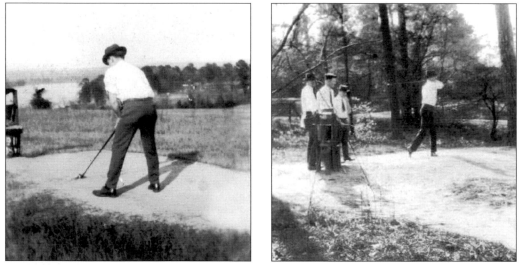

(left) MR. MORRIS, C. 1922. William S. Morris Jr., father of Morris Communications Chairman William S. Morris III, tees off on the Country Club of Augusta's Lake Course. Note the sandbox and water bucket at the far end of the teebox used to fashion tees out of sand; Lake Olmstead is in the background. (Courtesy Scott Nixon Collection, Augusta Museum of History.)

(right) TAKING FLIGHT, C. 1922. The three photos on this page are from the personal albums of photographer Scott Nixon, who recorded life in Augusta in the early 1900s. These photos were labeled "Scenes of the CC (Country Club of Augusta) Golf Links, February, 1922." The foursome is identified only from left to right as CB, WF, BM, and LF. "BM" has been indentified as William S. Morris Jr. (Courtesy Scott Nixon Collection, Augusta Museum of History.)

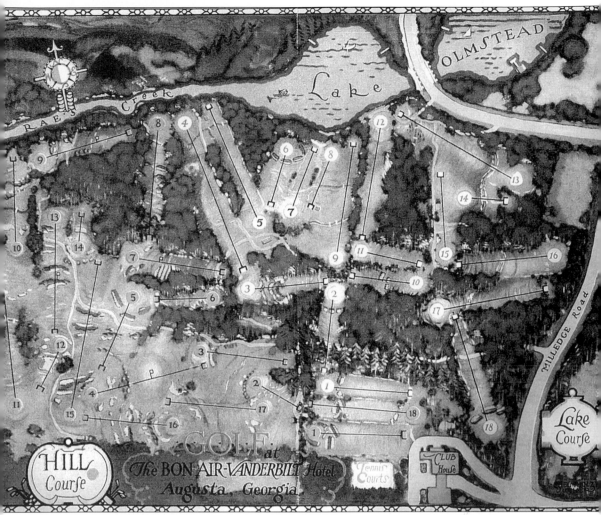

HILL AND LAKE COURSES, C. 1924. Shown here is a map of the Hill and Lake Courses as they appeared in 1924. Guests of the Bon Air and members of the Augusta Country Club had reciprocal rights to play either course. The inscription at the bottom of this map noted that "the two 18 hole golf courses are recognized as among the finest links in the country." Augusta's first nine-hole golf course and club house at the Bon Air were situated on the east side of Milledge Road. Country Club Hills subdivision is now located on land once occupied by the Lake Course. The North-South marker in the upper left hand corner is affixed on the approximate spot of the present-day 11th fairway at the Augusta National. (Courtesy Ross Snellings Collection.)

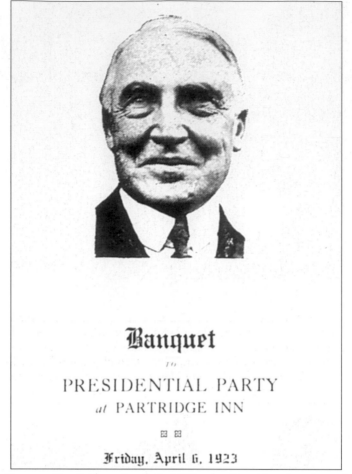

Banquet

to

PRESIDENTIAL PARTY
at PARTRIDGE INN

❀ ❀

Friday, April 6, 1923

PRESIDENTIAL PARTY. On Friday, April 6, 1923, the Partridge Inn hosted a banquet for President Warren G. Harding. Mayor Julian M. Smith welcomed the President to Augusta, and Judge A.L. Franklin of the Superior Court, Augusta District served as toastmaster for the event. Items on that evening's menu included "Essence of Augusta Chicken En Tasse, Broiled Savannah River Shad Maitre D'Hotel and Roast Stuffed Richmond County Turkey," with all the fixings.

President and Mrs. Warren G. Harding stayed at the rebuilt Bon Air-Vanderbilt during their vacation to Augusta, which took place the first week in April 1923. The President attended two Easter Services upon arriving in Augusta on Sunday, April 1, going first to First Baptist Church and then to a service at the Masonic Temple.

"President Plays Golf Over Country Club Course Here" proclaimed *The Augusta Chronicle* headlines on Tuesday, April 3, 1923, as President Warren G. Harding logged in 27 holes for the day. According to newspaper reports, the President had been playing so much golf that "although those who have been playing with Mr. Harding for the past four weeks would probably not admit it in the presence of the President . . . they had almost become 'golfed out.'" It would not be the last rounds the President would play during his vacation; the newspaper's headline the following day read, "President Plays Golf Despite April Showers." He was also scheduled to play golf and attend a polo match in Aiken that day, but rain postponed the outing. (Courtesy Augusta Museum of History.)

26

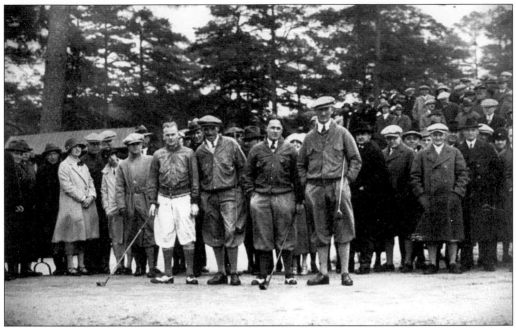

KEEPING UP WITH JONES, C. 1924. On a brisk day in March 1924, a highly publicized exhibition at the Augusta Country Club featured, from left to right, Southern champion Perry Adair, French Open champ Jimmy Ockenden, U.S. Open champion Bobby Jones, and British Open winner Arthur Havers. Ockenden and Havers defeated their American counterparts 5 and 4 in the match. (Photo by Montell; Courtesy Augusta Country Club.)

TILDEN AND TY, C. 1924. Tennis great Bill Tilden is shown in the umpire's chair during the 1924 South Atlantic States Tennis Championships at the Augusta Country Club. Tilden was the personal tennis coach of Ty Cobb Jr. and a frequent visitor of the Cobb house on William Street. Cobb Jr. excelled at tennis and football at Richmond Academy and later captained the Yale varsity tennis team, interned at University Hospital in Augusta, and became a well-respected general practitioner in Dublin, Georgia. (Photo by Montell; Courtesy Augusta Country Club.)

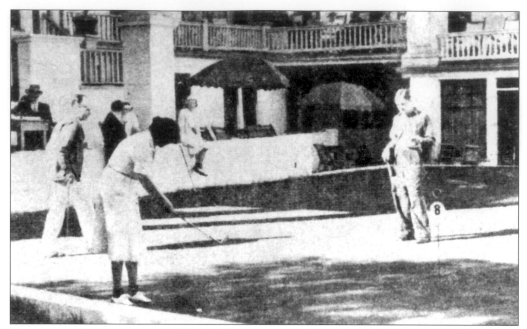

PARTRIDGE PUTTING, C. 1935. Golfers staying at the Partridge Inn were afforded the opportunity to sharpen their putting skills at any time on the large outdoor putting green, located at the site of the present-day swimming pool. The putting surface was a place to greet friends and discuss the topics of the day. (Courtesy Glover R. Bailie Jr., Augusta-Richmond County Historical Society, Reese Library, Augusta State University.)

TWO TEES, C. 1925. The Hill Course's 18th tee and the Lake Course's 2nd tee were in close proximity. The tees and greens on the Hill Course were converted to grass by Donald Ross after he finished construction of Forrest Hills Golf Course in 1926. Reports suggest that during that same year, Seth Raynor converted the Lake Course to grass. (Courtesy Claussen Collection, Augusta-Richmond County Historical Society, Reese Library, Augusta State University.)

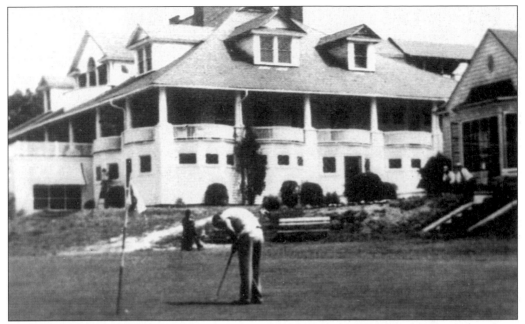

PUTTING GREEN, C. 1930. A lone golfer practices putting on the grass putting green in front of the original clubhouse at the Augusta Country Club. Note the Wallace House on the far right of the photo. (Courtesy Helen Callahan, Augusta-Richmond County Historical Society, Reese Library, Augusta State University.)

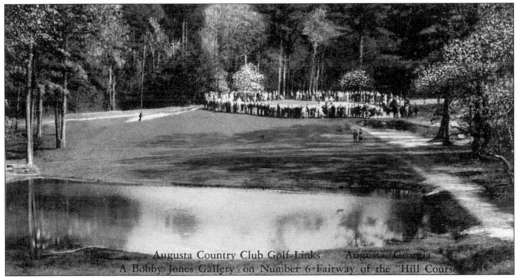

Augusta Country Club Golf Links Augusta, Georgia
A Bobby Jones Gallery on Number 6 Fairway of the "Hill Course"

WATCHING BOBBY JONES, C. 1930. This postcard proclaims a Bobby Jones gallery on the sixth hole of the Hill Course. Four years prior to winning the Grand Slam, Jones had already won a handful of major titles and was accorded an honorary lifetime membership at the club. The first two rounds of the Southeastern Open in 1930 were staged over the Augusta Country Club's 6,632-yard, par-72 Hill Course, with Jones taking a narrow lead heading to the final two rounds at Forrest Hills. Winning the event by 13 shots, Jones later reflected on the events of his Grand Slam year, saying the Southeastern Open was the best tournament golf he ever played. (Courtesy Joseph M. Lee III.)

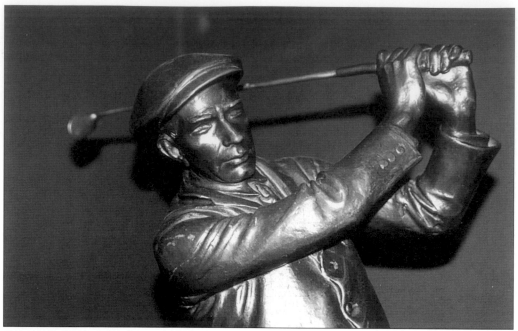

OGILVIE'S OWN. This bronze statue in the trophy room of the main clubhouse pays tribute to David Ogilvie's nearly half-century as head professional at the Augusta Country Club. Ogilvie's contributions includes service dating back to 1899 as the first and only head professional of the Bon Air Golf Club. (Photo by Stan Byrdy; Courtesy Augusta Country Club.)

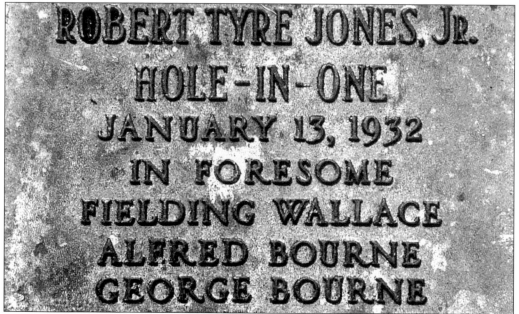

HOLE IN ONE. Bobby Jones scored the second hole-in-one of his career while playing golf at the Augusta Country Club on January 13, 1932. This plaque at the 14th tee marks the occasion. Playing in a "foresome" that included Alfred S. Bourne, his brother George, and club president Fielding Wallace, Jones used a four-iron on the 136-yard, par-3 hole. One year to the day later, Jones officially opened the doors to the Augusta National Golf Club. (See page 120.)

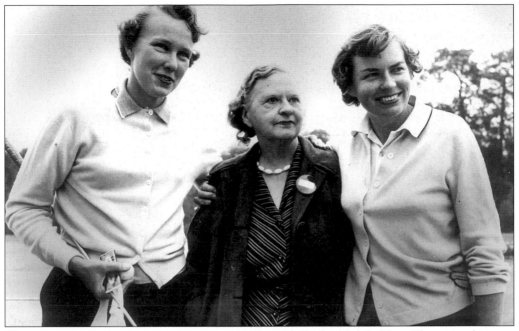

WRIGHT AND RAWLS'S, C. 1959. From 1937 to 1966, the Titleholders Championship was staged at the Augusta Country Club. Pictured from left to right are Mickey Wright, who would go on to win the championship twice, and Mrs. Rawls along with daughter Betsy, who finished runner-up on three occasions. Augustan Eileen Stulb placed runner-up in two championships (1942 and 1946). A major tournament on the ladies tour, the unique event showcased the top women amateur and professional champions. (Photo by Hugh Cross; Courtesy Women's Titleholders Golf Association.)

MAJORS MONEY. One of the first tournaments to offer prize money to lady professionals, the Titleholders' total purse in 1948 was $600. Prize money was awarded to the top three professionals in the field, with first place receiving $300. A 54-hole event in three of the first six years it was staged, the championship changed to 72 holes permanently in 1946 and played out over the 6,351-yard Hill Course at the Augusta Country Club. The Titleholders Championship was founded by Dorothy J. Manice. (Photo by Robert Wilkinson; Courtesy the Augusta Museum of History.)

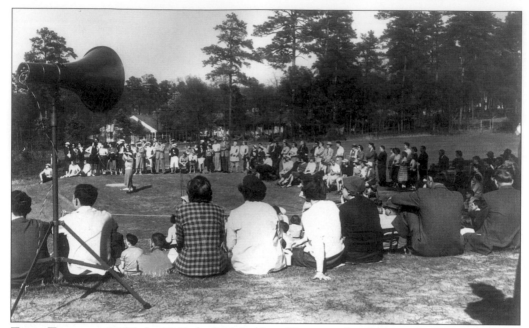

TITLE TOWN, C. 1955. In 1942 the Titleholders Championship became the longest running 72-hole medal play event for women in the United States. Dorothy J. Manice, Fielding Wallace, Eileen Stulb, David Ogilvie and daughter Isabel, Augusta golf benefactor Alfred S. Bourne, and Armed Forces (Forest Hills) head pro Mickie Gallagher Sr. were instrumental in the championship's success. (Courtesy Women's Titleholders Golf Association.)

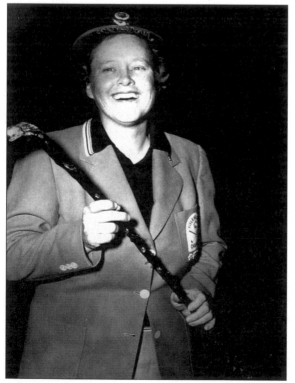

ST. PATTY'S DAY. Jack Nicklaus has won the Masters Tournament six times, but Patty Berg holds the mark for the most majors won in Augusta with seven, including wins in the first three Titleholders Championships (1937–1939) as an amateur. Berg also finished runner-up in the event on four occasions. Donning the green jacket for her final Titleholders Championship on St. Patrick's Day 1957, Berg remarked that she "was lucky." (Courtesy Women's Titleholders Golf Association.)

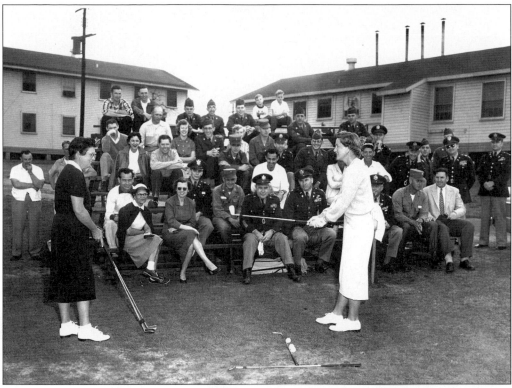

TITLEHOLDERS CLINIC, C. 1965.
The 1960 Titleholders champion
Fay Crocker and two-time winner
Marilynn Smith host a clinic for
soldiers at Fort Gordon. Smith
won her Titleholders
Championships in successive
years, 1963 and 1964. (Photo by
Robert Wilkinson; Courtesy the
Augusta Museum of History.)

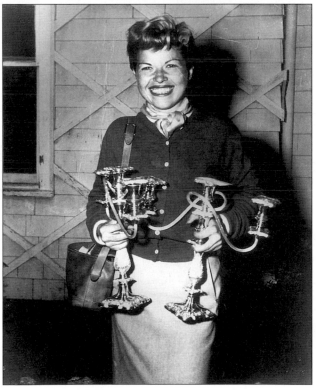

BARBARA'S BOUNTY, C. 1954.
Barbara Romack is all smiles as
she holds hardware for being low
amateur in the 1954 Titleholders,
won by Louise Suggs. Beginning
in 1955, the outstanding amateur
to post the lowest score through
four rounds was awarded the
Dorothy J. Manice trophy, in
honor of the tournament's
founder. (Courtesy Women's
Titleholders Golf Association.)

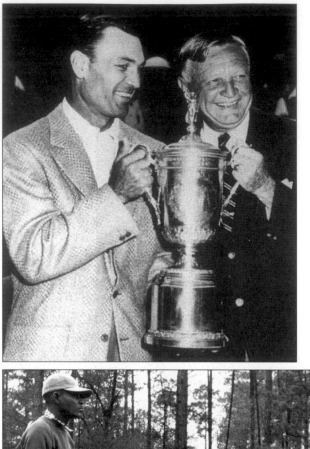

FIELDING AND FRIEND, C. 1948. During his 14 years as president (1921–1935), Fielding Wallace ushered in an era of change at the club, overseeing the name change to Augusta Country Club, the switch to grass greens, and the construction of Wallace House in his honor. He also helped Bobby Jones found the Augusta National Golf Club. Wallace later became president of the USGA and was enshrined in the Georgia Golf Hall of Fame in 1992. He is shown here presenting Ben Hogan with the 1948 U.S. Open Championship trophy. (Courtesy Augusta Country Club.)

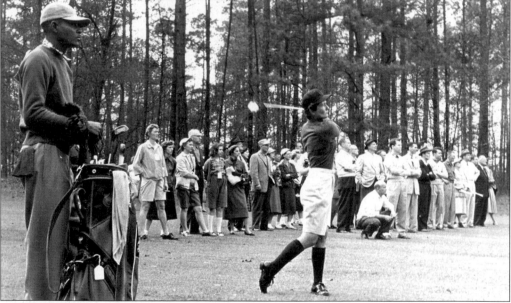

SUGGS'S SWING, C. 1959. Louise Suggs won the Frank J. Miller Cup and $1,000 for the 1959 Titleholders Championship. The original Titleholders trophy was stolen from the car of winner Babe Zaharias in Cleveland in 1950 and was never recovered. The Frank J. Miller Titleholders Championship trophy is housed today at LPGA Headquarters in Daytona Beach, Florida, along with the Dorothy J. Manice cup and the Glenna Collett Vare award, which is given to the LPGA member with the season's lowest scoring average. Suggs was inducted into the Georgia Golf Hall of Fame in 1989. (Courtesy Women's Titleholders Golf Association.)

SISTER ACT. Marlene and Alice Bauer made for a tough act to follow on "Fun Night" in 1953 at the Augusta Country Club. (Photo by Frank Christian; Courtesy Women's Titleholders Golf Association.)

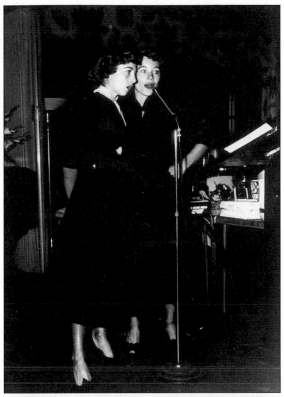

PATTY'S PARTY. A popular attraction staged at the Augusta Country Club prior to the start of each tournament was the entertaining "Fun Night." Featured in a special program entitled "This is Your Life, Patty Berg," which was presented in 1957, are, from left to right, Wiffi Smith, Jo Ann Prentice, Betty Jamison, Patty Berg, Alice Bauer, Augusta's own Eileen Stulb, Bonnie Randolph, and Pat Devaney. Stulb portrayed Oklahoma football coach Bud Wilkinson in the program, a childhood friend of Berg's on the sandlots of Minneapolis. (Photo by Hugh Cross; Courtesy Women's Titleholders Golf Association.)

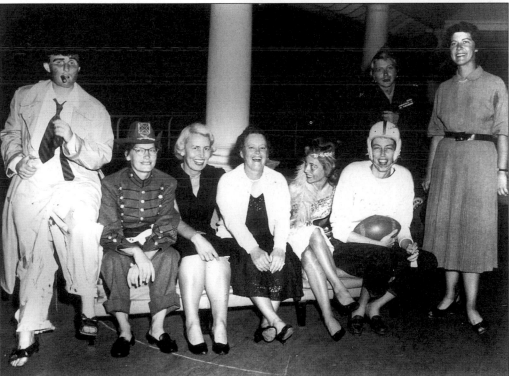

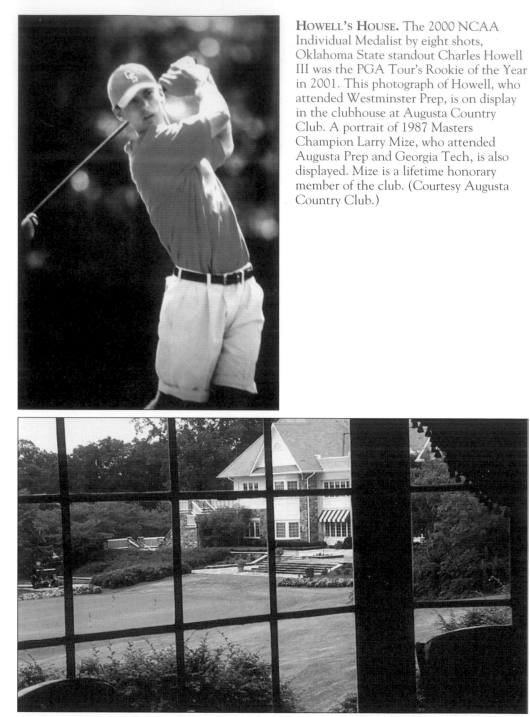

HOWELL'S HOUSE. The 2000 NCAA Individual Medalist by eight shots, Oklahoma State standout Charles Howell III was the PGA Tour's Rookie of the Year in 2001. This photograph of Howell, who attended Westminster Prep, is on display in the clubhouse at Augusta Country Club. A portrait of 1987 Masters Champion Larry Mize, who attended Augusta Prep and Georgia Tech, is also displayed. Mize is a lifetime honorary member of the club. (Courtesy Augusta Country Club.)

WALLACE HOUSE. This view taken from Wallace House looks out at the current Augusta Country Club. Named in honor of longtime club president Fielding Wallace, the building was a gift to the club by Alfred S. Bourne in 1929. Between 1937 and 1966, Wallace House was utilized as tournament headquarters for the Titleholders Championship. (Photo by Stan Byrdy; Courtesy Augusta Country Club.)

Two

PALMETTO PRIDE

Located just across the Savannah River from Augusta is the state of South Carolina, officially known as the Palmetto State and home to nearby North Augusta and Aiken. While Aiken has long been associated with horses and North Augusta is no longer a winter tourism resort, combined with Augusta, the trio has left a lasting mark on golf history.

Constructed in the 1860s, Highland Park was Augusta-Aiken's pioneer in grand-style hotels and helped establish Aiken as a health resort. By the turn of the century, the Willcox Inn and Park in the Pines Hotel were built, and Tommy Hitchcock, friend William C. Whitney, and other acquaintances transformed Aiken into the "Newport of the South," "Queen of Winter Resorts," and the "Winter Polo Capital of America." When Hitchcock designed four holes with sand greens at Palmetto Golf Club in 1892, the first golf course in the Southeastern United States was born. It also marked the birth of golf in the Augusta-Aiken area and foreshadowed an even bigger chapter in sports history.

Every bit as imaginative as Bobby Jones's dream for the Augusta National was James U. Jackson's vision of first founding, then transforming North Augusta into an elegant resort town. For 25 years, Jackson's dream shaped reality in North Augusta, with the Hampton Terrace Hotel and Golf Course as the driving force behind unparalleled growth in Augusta-Aiken's winter tourism industry. During Jackson's heyday, a bridge spanning the Savannah River was erected. A trolley system shuttling visitors between Augusta, North Augusta, and Aiken was put in place. And the Hampton Terrace Hotel, reported to be the largest wooden structure in the world at the time, was built in less than one year.

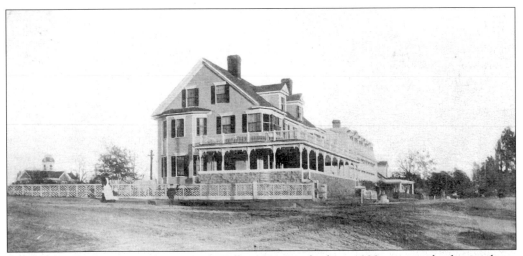

WILLCOX INN, C. 1912. The original Willcox Inn was built in 1898, sustained a fire, and was rebuilt in 1900 at its current location on the corners of Chesterfield Avenue and Colleton Street in Aiken, where railroad tracks pass just in back of the structure. The Willcox expanded in 1906 to include a ballroom and was enlarged again in 1928. The inn was open from October to May, and Franklin D. Roosevelt, Winston Churchill, and Mrs. John Jacob Astor were among its notable guests. The Prince of Wales was reportedly once turned away as no rooms were available during a busy Masters Week. (Courtesy Augusta Museum of History.)

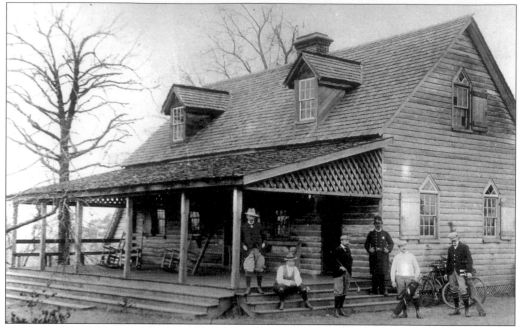

ORIGINAL CLUB HOUSE, C. 1900. The former home of the W.C. Tibbitts family of Aiken, the original clubhouse at Palmetto Golf Club was this two-story structure that served the club well for a decade until the current clubhouse was built in 1902. (Courtesy Palmetto Golf Club.)

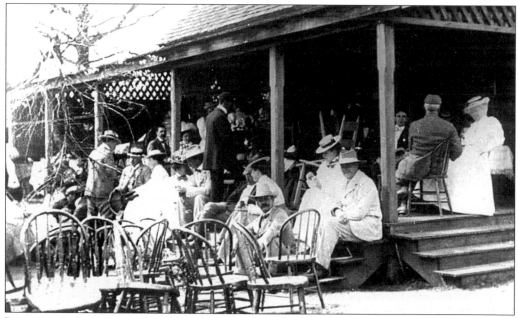

LUNCH IS SERVED, C. 1900. A center for social events, the original clubhouse porch was where lunch was served in this turn-of-the-century photo. Note the overhang, steps, and lattice work from the picture above. (Courtesy Palmetto Golf Club.)

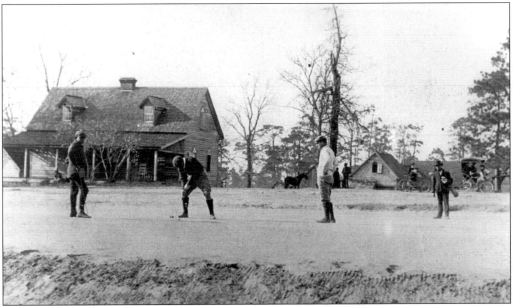

USGA MEMBERSHIP. The 30th member of the USGA, Palmetto Golf Club proudly displays its original certificate dating to January 1896 in the club's pro shop. It is the second-oldest USGA certificate in existence. (Courtesy Palmetto Golf Club.)

GIMME PUTT. The original clubhouse appears in the background of this turn-of-the-century photo showing golfers putting on the 18th (sand) green. Note the long boots the golfers are wearing, the youngsters with bicycles, and the horse and carriage in the background. (Courtesy Palmetto Golf Club.)

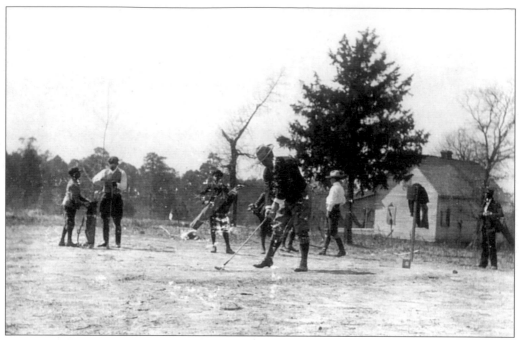

GOLF'S GOLDEN AGE, C. 1895. Club founder Tommy Hitchcock and friends tee it up at Palmetto Golf Club in 1895 in two of the oldest photos on record of golfing in the Augusta-Aiken area. By the time these pictures were taken, Palmetto had expanded from four holes to nine, and within two years it would grow again, to eighteen holes. Throughout the years, Palmetto Golf Club has hosted some of the greatest golfers of all time. Reigning British Open Champion Harry Vardon paid a visit to the club with the Prince of Wales in 1900. Vardon also played golf at the Country Club of Augusta's original Bon Air Course and later that year won the U.S. Open. (Courtesy Palmetto Golf Club.)

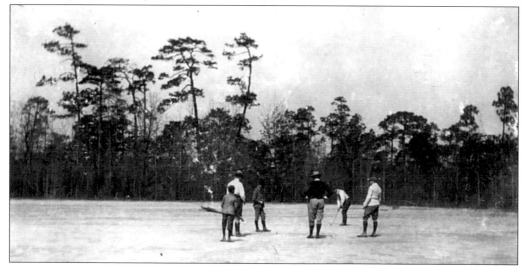

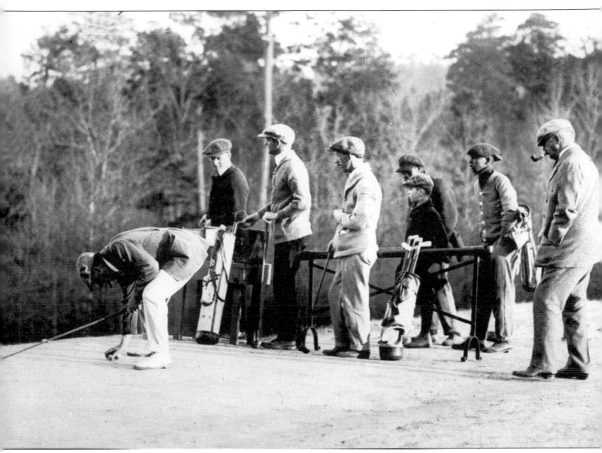

"BENDING" THE RULES. Note the number of golf clubs being carried in this turn-of-the-century photo taken at Palmetto Golf Club in Aiken. In the early 1900s, a standard set consisted of eight clubs, comprised of either persimmon or hickory shafts. (Courtesy Palmetto Golf Club.)

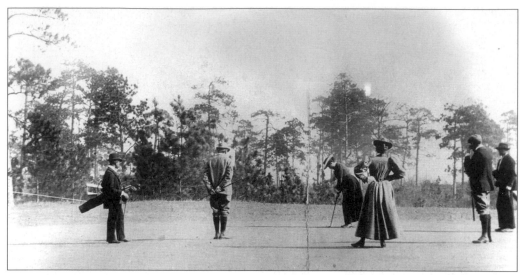

SHORT PUTT, LONG DRESS, C. 1900. At the turn of the century, golf was a game for older men with the time and money to play, and it was also played on occasion by women. Young men did not play the game and reportedly lost favor if they did. Note the women in long dresses and heeled shoes. The original course played at 5,833 yards. (Courtesy Palmetto Golf Club.)

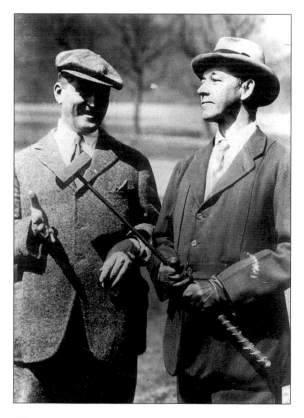

TRAVERS'S TROPHY, C. 1925. The first American to win the British Amateur Championship, Walter Travers (left) shows to Palmetto member Harry Payne Whitney the Schenectady-style putter used by Travers to win the title in 1904. (Courtesy Palmetto Golf Club.)

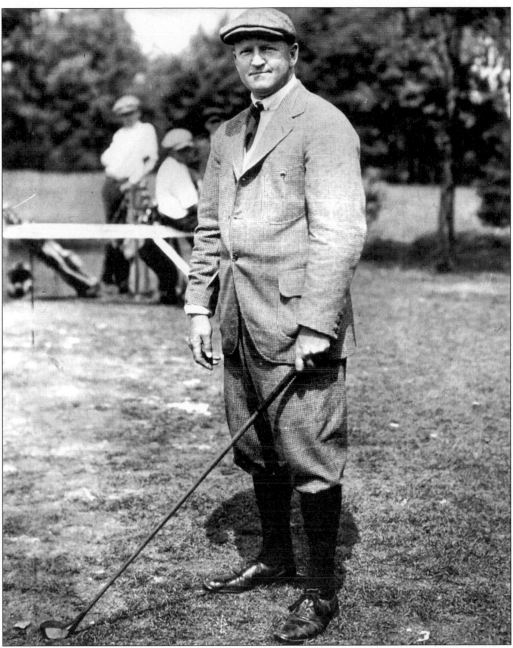

PALMETTO'S PRESIDENTIAL TIES. An early member of the club, George Herbert Walker is the great grandfather of U.S. President George Walker Bush and the grandfather of former U.S. President George Herbert Walker Bush. Note the uncanny resemblance to the current President. Walker was also donor of the Walker Cup that is contested biennially between golfers in the U.S. and Great Britain-Ireland. Palmetto's Bobby Knowles represented the United States in a winning match during the 1951 Walker Cup competition. (Courtesy Palmetto Golf Club.)

SOCIAL CLIMATE, C. 1910. Palmetto Golf Club was a social center for the Winter Colony that vacationed in Aiken, where a festive social gathering takes place outdoors on a sunny winter day in the early 1900s. (Courtesy Palmetto Golf Club.)

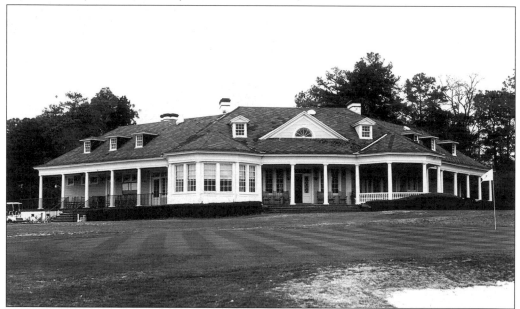

CENTURY CLUB, C. 1965. Built in 1902, the clubhouse at Palmetto Golf Club is the second-oldest in the nation at 100 years old, next to Shinnecock Hills, which was constructed in 1892. Both structures were designed by Stanford White of the noted architectural firm McKim, Meade and White of New York City. Little has changed to this built-to-last clubhouse with strong, classic lines, and its original locker rooms. Wooden inscribed trophy boards also remain in excellent condition. (Courtesy Palmetto Golf Club.)

BROOKLINE BOBBY. Bobby Jones appears with Bobby Knowles's mother, Amy Thorp Knowles, at the 1934 U.S. Amateur Championship at Brookline Country Club. Bobby Knowles notes that Bobby Jones and Clifford Roberts frequented the links at Palmetto Golf Club in the early 1930s prior to construction of the Augusta National. At least a half dozen members of Palmetto Golf Club became founding members of Jones's new club in Augusta. (Courtesy Palmetto Golf Club.)

FIVE TO DRIVE, C. 1935. Taken on the first tee at Palmetto Golf Club, this photo includes, from left to right, Jack Jolly, Mickie Gallagher Sr. (who served as assistant pro at Hampton Terrace Golf Club, professional starter at the Country Club of Augusta, head pro at the Armed Forces Golf Club at Forest Hills, and was a driving force behind the Titleholders Championship at Augusta Country Club), Joe Sewall, Alfred S. Bourne (Augusta golf benefactor and Augusta National organizer), and Jimmy Mackrell (Palmetto's first golf professional). (Courtesy Palmetto Golf Club.)

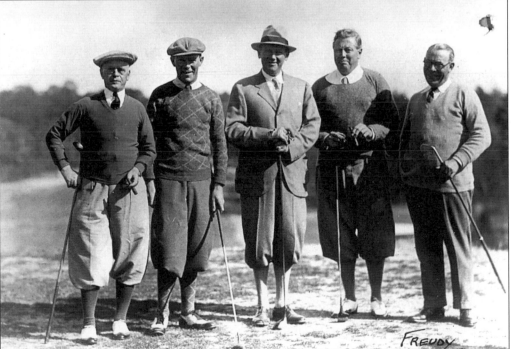

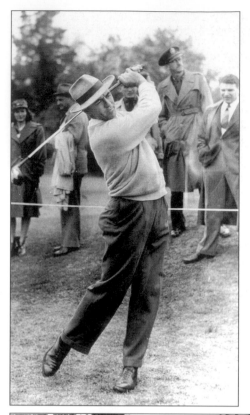

SLAMMIN' SAM. Sam Snead takes part in the Red Cross exhibition of 1945. Snead is shown here teeing off on the first hole of the match, which raised $500 for the charity's war efforts. With the onset of World War II, membership at Palmetto Golf Club dropped and in 1942, playing privileges were extended to in-state members of nearby Aiken Golf Club and army officers at Camp Gordon near Augusta for a greens fee of $2. Members of the Augusta Country Club were also welcome to play for a greens fee of $3. (Courtesy Palmetto Golf Club.)

RED CROSS EXHIBITION. The cover photo for this book was taken at Palmetto Golf Club in 1945 as Sam Snead, Byron Nelson, Craig Wood, and Sam Byrd took part in an exhibition that raised $500 for the Red Cross. Here, Snead drives from the 16th tee while Palmetto members Jimmy Johnson and golf pros Sam Byrd, Craig Wood, and Byron Nelson, pictured from left to right, look on. When this photo was taken, Wood (1941) and Nelson (1942) had already won the Masters Tournament, and Snead would later win three times (1949, 1952, 1954). Byron Nelson won the match that day. (Courtesy Palmetto Golf Club.)

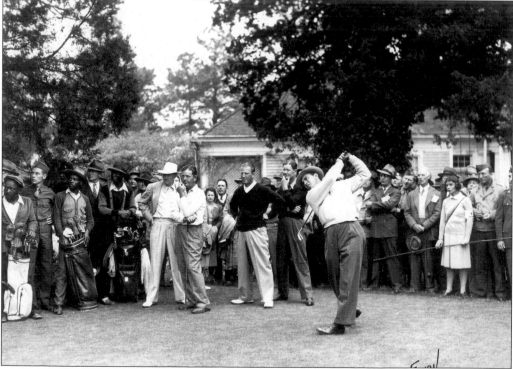

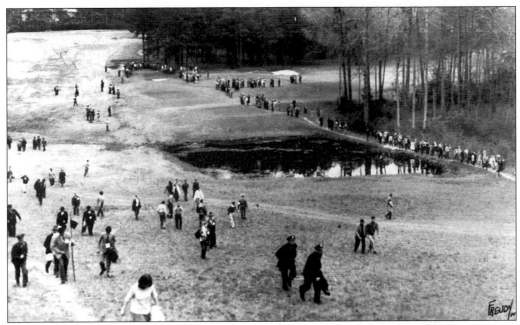

PRO-AM PATRONS, C. 1950. Patrons walk the fairways of Palmetto Golf Course during one of the club's pro-am events. From 1945 to 1953, the Devereux Milburn Tournament attracted the world's top professionals. Ben Hogan came back from a debilitating car accident to win the event with amateur Bobby Goodyear in 1952. The following year, Hogan won the three majors he entered—the Masters in neighboring Augusta, along with the U.S. and British Opens. (Courtesy Palmetto Golf Club.)

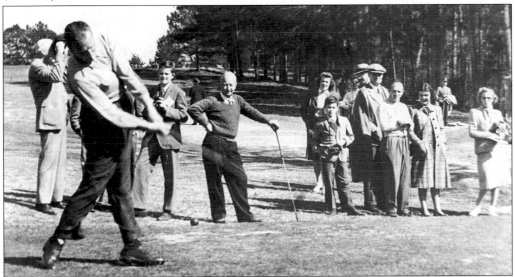

WOOD MAKES GOOD, C. 1945. The 1941 Masters champion Craig Wood makes good contact from the fairway during a round of golf at Palmetto Golf Club. Staged annually for over 50 years at Palmetto is a tournament named in honor of Devereux Milburn, a member with a lasting impact on the club. The tournament was staged as a pro-am from 1945 to 1953, with Byron Nelson, Henri Picard, Herman Keiser, and Ben Hogan heading up teams that placed first. Since 1954, the event has been contested as a member-guest format. (Courtesy Palmetto Golf Club.)

THREE'S COMPANY. The great grandson of poet Henry Wadsworth Longfellow, noted amateur golfer Bobby Knowles (center) is flanked by Dot Rogers and Bing Crosby at Palmetto Golf Club. On June 1, 1951, Knowles defeated Henry De La Maze 3 and 2 to capture the French Amateur Championship in Chantilly, France. The putter he used that day is on display in the Palmetto Golf Club pro shop. (Courtesy Palmetto Golf Club.)

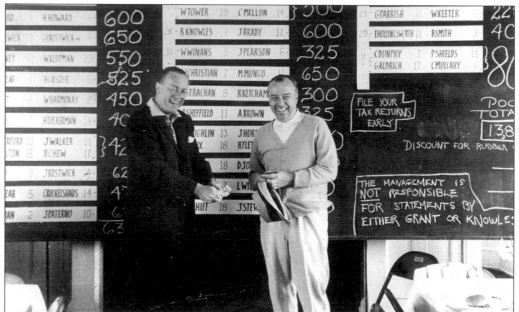

CALCUTTA. Freddie Kammer (left) and Bobby Knowles (right) stand in front of the then legal Calcutta pairings for the Devereux Milburn Pro-Am tournament in late March 1955. Note the message on the chalkboard, "File your tax returns early," along with a disclaimer by management for statements made by Knowles. Also listed is the total pool money of just under $14,000 taken in for the event. (Courtesy Palmetto Golf Club.)

WATCH MY BACK, C. 1950. Jimmy Demaret tees it up at Palmetto Golf Club as Bobby Knowles (far left) and Sam Snead (center) look on. Demaret won the Masters Tournament in 1940, 1947, and 1950, with Snead posting wins in 1949, 1952, and 1954. A standout amateur, Knowles played in two Masters Tournaments, his first in 1951. That summer, Knowles played a winning role on the 1951 Walker Cup team and followed up with a victory in the French Amateur Championship. (Courtesy Palmetto Golf Club.)

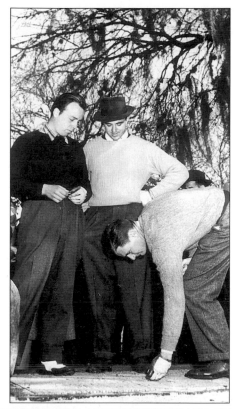

HOGAN PREVAILS. Into the winners circle in the 1952 Devereau Millburn Pro-Am is Ben Hogan on the left and Bobby Goodyear on the far right. Presenting the esteemed trophy is club president Eugene Grace (who partnered with Byron Nelson to win Palmetto's first Pro-Am in 1945) and vice president Edmund Rogers. Herman Keiser and Henri Picard were on opposing teams that finished in a three-way tie for the title in 1948. The Pro-Am was changed to a member-guest event in 1954, the format in which the tournament is contested today. (Reprinted from the Palmetto Golf Club Book, *The First One Hundred Years*; courtesy Palmetto Golf Club.)

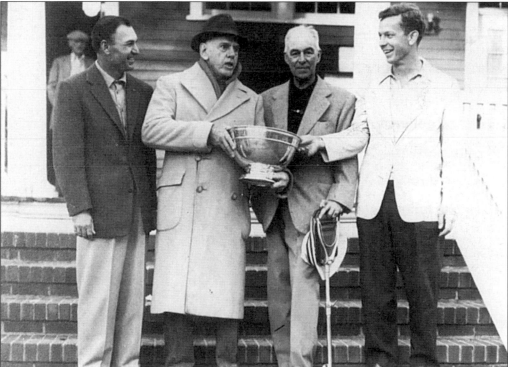

HEADING HOME. This 1930s aerial view showcases the final three holes of the Alister McKenzie–redesigned Palmetto Golf Course and the classic Stanford White–designed clubhouse. Tommy Hitchcock's original four holes with sand surfaces were located over the closing three holes in this picture. The oldest golf club in the Southeast, Palmetto Golf Club is acknowledged by the USGA as being between the fifth- and twelfth-oldest club in the nation,

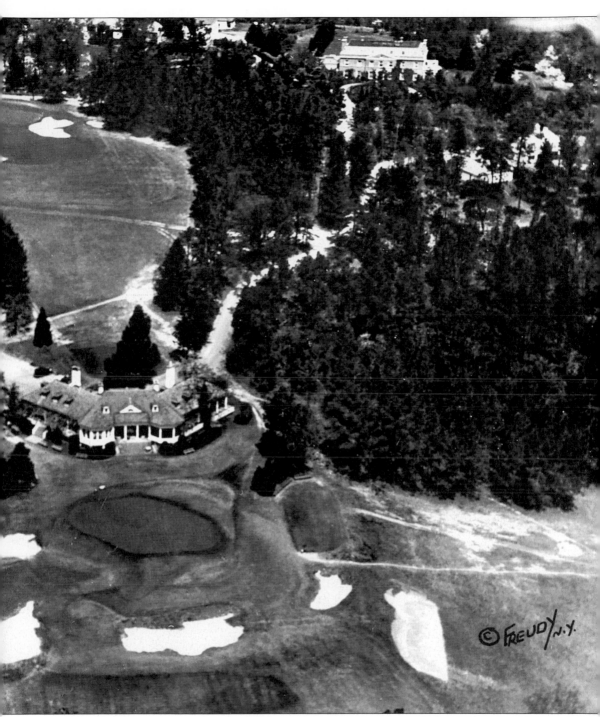

dating back to 1892. Known as the "Queen of Winter Resorts" and the "Polo Capital of America," Aiken's combination of resort hotels, accessibility by rail, and moderate winter climate made it one of the top winter destinations for the rich and famous in the United States. (Courtesy Palmetto Golf Club.)

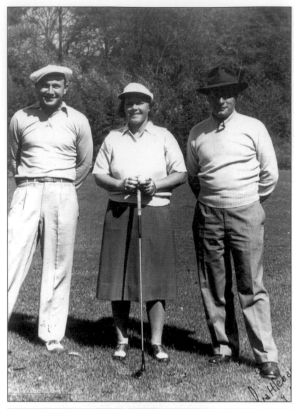

PATTY AND PALS. Patty Berg (center) is flanked by Mike Lucas (left) and Palmetto head professional Bert McDougal (right) at Highland Park in 1948, the year Berg won the fourth of her seven Titleholders Championships. She was also victorious in the inaugural Women's Invitational in Aiken in 1937 at Highland Park. (Courtesy Palmetto Golf Club.)

BING AND BOBBY. Bing Crosby and distinguished amateur Bobby Knowles made for a pair of formidable playing partners during the 1950s. Knowles relates that Crosby could "break 80" if his mind was not on show business, but if working on a project, his scores would suffer. Knowles was influential in helping persuade Augusta National chairman Clifford Roberts make the change to a system depicting golfers scores in relation to par, the modern-day scoring system first used during the Masters Tournament in 1953. (Courtesy Palmetto Golf Club.)

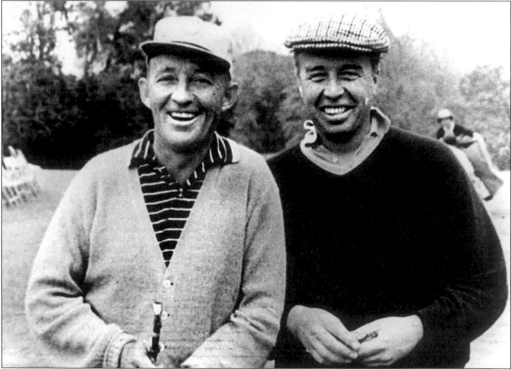

GOLDEN TOUCH. Barry Goldwater (second from right) took part in the 1964 Devereux Millburn Championship with member Jack Parker (left). Mrs. Goldwater (center) and Frances Smoak also appear in this photo. Northrup Knox and H.A. Fletcher won the club's prestigious tournament that year. (Courtesy Palmetto Golf Club.)

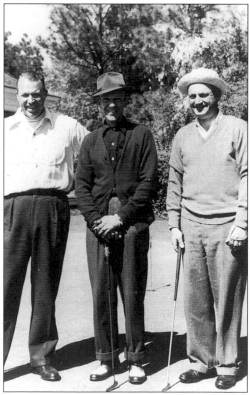

CELEBRITY GOLF. Fred Astaire is flanked by Palmetto members Eddy Blind (left) and John Gaver (right). Astaire also toured the Aiken Golf Club in 1940, paying his greens fee of $4 to head pro Joe Frasca. In 1945, Frasca succeeded David Ogilvie as head golf professional at the Augusta Country Club. (Courtesy Palmetto Golf Club.)

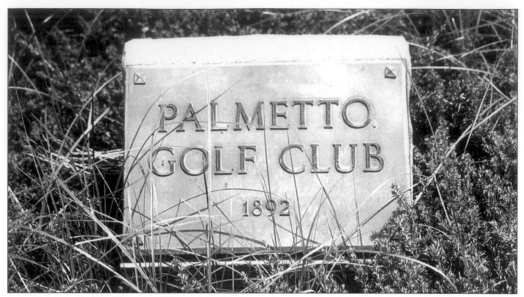

MARKER. In 1892, Thomas Hitchcock laid out four holes for golf and founded the Palmetto Golf Club, the first golf club in the Southeastern United States. The USGA recognizes Palmetto as between the fifth- and twelfth-oldest club in the nation. This marker in front of the clubhouse commemorates Palmetto's proud standing as one of the oldest golf clubs in America. In 1997, Brennen King posted a 61 to establish the single-round scoring record at Palmetto Golf Club, edging Frank Lock's mark of 62, which had stood for 29 years. Three-time Master's Champion Sam Snead was one of several golfers to share the club's early scoring record of 63. (Photo by Stan Byrdy; Courtesy Palmetto Golf Club.)

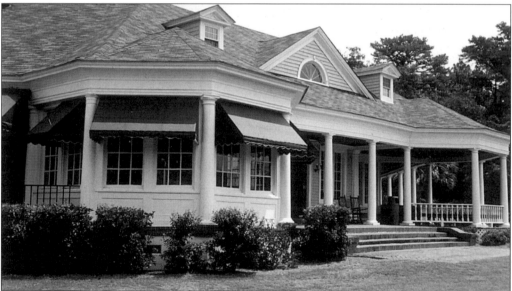

CLUBHOUSE. Very little has changed at the 100-year-old clubhouse at Palmetto Golf Club in Aiken. Head golf professionals have also enjoyed long tenure at Palmetto, with Tom Moore celebrating his 20th anniversary in 2002. Moore made the move from West Lake Country Club in Augusta in 1982, where he trained under the watchful eye of Georgia Golf Hall of Fame member Mark Darnell. (Photo by Stan Byrdy. Courtesy Palmetto Golf Club.)

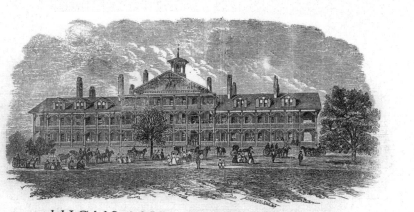

HIGHLAND PARK HOTEL,
AIKEN, S. C.

THIS NEW HOTEL has accommodations for one hundred and fifty guests. Has every requisite of a popular resort, and an advantage of location as to climate not equalled by any other resort in the South. The dry atmosphere and uniform temperature during the Spring months, produce the most satisfactory results looked for by Northern visitors.

~AIKEN~

Is reached by the Direct Routes to the North, is but 17 miles East from Augusta, and 120 miles West from Charleston, on S. C. R. R.

Season closes 1st to middle of June.

Prices for Board are reasonable, varying according to location of room.

Address by Mail or Telegraph, Highland Park Hotel.

B. P. CHATFIELD, Prop'r.

E. H. TOMLINSON, Manager.

NOTE.—*A large and well stocked Livery Stable connected with the House.*

HIGHLAND PARK, C. 1870. Built in the late 1860s, the original Highland Park Hotel is being advertised in this image. (Courtesy Lista's Studio of Photography.)

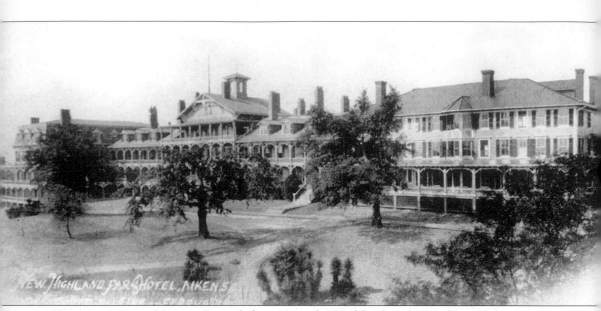

HIGHLAND PARK HOTEL. Expanded in 1874, the Highland Park Hotel was Aiken's largest grand resort of the late 1800s. Pine-laden forests, favorable winter climate, and ease of access by rail made Aiken one the most popular winter destinations in the United States. Boasting outstanding facilities for riding, jumping, polo, and horse shows, Aiken was quickly established as the nation's foremost winter locale for equestrian sports. The Winter Colony could also partake of Aiken's two fine golf courses at Palmetto Golf Club and, starting in 1912, the Highland Park Golf Club. (Courtesy Lista's Studio of Photography.)

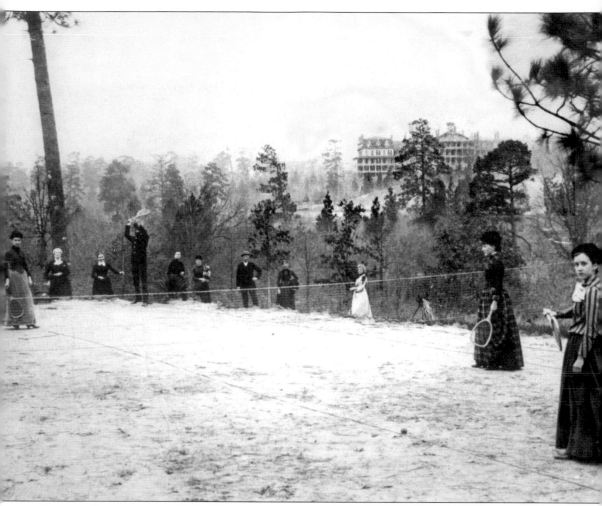

WHAT A RACQUET, C. 1895. The racquet sports of badminton and tennis were extremely popular with the Winter Colony who vacationed in the Augusta-Aiken area. The stately Highland Park Hotel casts a ghostly outline on the horizon. Considered one of the finest hotels in the South, the Highland Park featured a half-mile of porticoes and piazzas on which vacationers could stroll. Open from November to June, the hotel included baths with hot and cold running water on each floor and all rooms equipped with an electric service bell. The playground for Aiken's Winter Colony, Hitchcock Woods comprised the largest city park in the United States. (Courtesy Lista's Studio of Photography.)

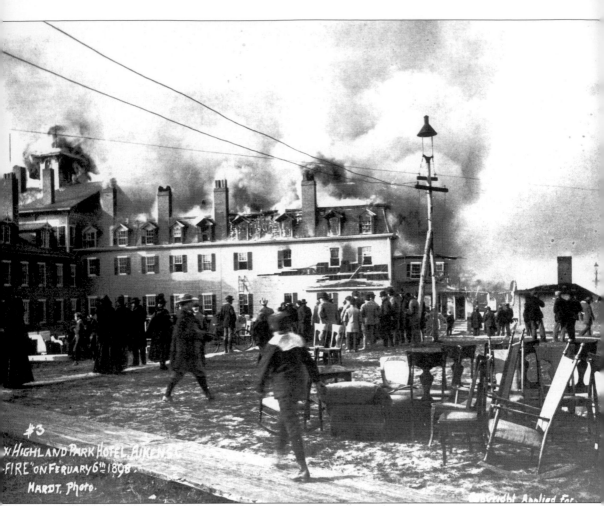

ABLAZE IN AIKEN. The front-page headlines of *The Augusta Chronicle* of Monday, February 7, 1898 declared "Yesterday's Destructive Fires" in reference to fires the previous day that destroyed the Highland Park Hotel in Aiken and the Cathedral of St. John the Baptist in Savannah. In bold print, the newspaper reported, "Highland Park Hotel Licked Up By Flames," "Pride of Aiken Is a Smoldering Mass of Embers," "Guests Escape Without Injury." It also noted that many of the guests had gone on to Augusta's Hotel Bon Air. The hotel was described by the newspaper as "the boast of all Carolina; the rendezvous of the richest of the rich Americans who compose the upper crust of New York society." The fire apparently started in or around the basement laundry at about 5:30 a.m. on Sunday and did not spread quickly at first, affording time to awaken those sleeping inside. "Handsome furniture, pianos, iron bedsteads, feather beds and numerous other articles of hotel furnishings and luxuries lay strewn about. Here and there a tennis racket, and yonder a caddy of golf sticks told of the sports that had for a time a stop put to them." Insufficient water pressure hampered firemen, but "four streams [of water] were playing on the fire shortly after it first started, and for a time it looked as though its progress would be stopped." Some 300 people were displaced by the blaze, including 120 members of the Highland Park staff. The loss at Highland Park was placed at $150,000, with $98,000 insured. The hotel was rebuilt and partially burned again in 1939. (Courtesy Lista's Studio of Photography.)

NEW HIGHLAND PARK HOTEL. Rebuilt after the fire of 1898, the New Highland Park featured a Spanish exterior. Billed as Aiken's largest and finest hotel, the new structure boasted 125 well-appointed rooms on 400 acres of land. The hotel's main floor featured a large lounge, sun parlor, fireplace, and colonial dining room. Menu items were brought in from markets afar— meat from New York, seafood from Boston, and fruits and vegetables from California and the far South. When a second fire burned the structure in 1939, the estate went into bankruptcy and was offered for sale at the price of $70,000. The city of Aiken purchased the golf course for $15,000 and changed its name to the Aiken Golf Club, naming assistant Joe Frasca as new head pro to replace John R. Inglis. (Courtesy Lista's Studio of Photography.)

TEE TIME, C. 1915. Ladies tee it up at Highland Park Golf Course. The staff promoted women's golf, and in the late 1930s, Highland Park hosted a national invitational for women. Highland Park is reported to be the first golf course in the nation to have installed separate tees for women. (Courtesy Palmetto Golf Club.)

HIGHLANDS AND LOWLANDS, C. 1939. This view of the scenic 16th green at Highland Park (Aiken Golf Club) looks back toward the tee of the challenging downhill par-3 setup. When the course opened in 1912, par was 67. Today's par 70 design plays 6,048 from the Medal Tees, 5,685 yards from the Mid Tees, and 4,730 yards from the Fore Tees. Donald Ross converted the course from sand to grass greens between 1931 and 1932. (Courtesy Lista's Studio of Photography.)

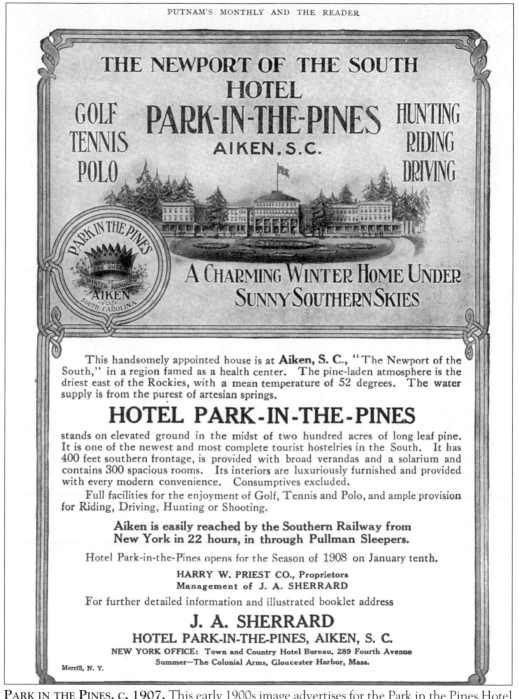

PARK IN THE PINES, C. 1907. This early 1900s image advertises for the Park in the Pines Hotel in Aiken. Constructed around 1900 near the southwest corner of Hampton Avenue and Morgan Street, the hotel burned during the winter season of 1913. Its Pine Tree Clubhouse, which was utilized as a gambling casino, caught on fire in 1927. The hotel also maintained a nine-hole golf course situated near the present-day location of Aiken Prep. (Courtesy Lista's Studio of Photography.)

HIGHLAND PARK HAPPENING. Featuring top women golfers of the day, the inaugural Women's Golf Invitational at Highland Park Golf Club took place in March 1937. The following year, the format changed to team competition to ensure a complete field throughout the week. The tournament marked Aiken's initial foray in staging a major women's event, and according to a report in the March 20, 1937 edition of *The Augusta Chronicle*, the tournament was hailed as a "huge success." From the clubhouse, it was approximately 200 yards to the Highland Park Hotel located on the highest hill in Aiken. (Courtesy Aiken County Historical Society.)

HIGHLAND PARK GOLF COURSE Aiken, S. C.				Self	*womans Record march 13*		REPLACE DIVOTS			W x L — H o				
Hole	Yards	Par	Handicap Stroke	Self			Hole	Yards	Par	Handicap Stroke	Self			
1	385	4	9	4			10	466	5	1	4			
2	360	4	6	4			11	215	3	13	4			
3	380	4	5	6			12	300	4	11	5			
4	140	3	16	3			13	409	4	3	5			
5	435	4	2	4			14	130	3	18	3			
6	318	4	10	4			15	300	4	12	4			
7	385	4	4	4			16	175	3	15	3			
8	355	4	7	4			17	340	4	8	5			
9	135	3	17	4			18	190	3	14	3			
Out	2893	34		37			In	2525	33		36			
Player *Babe Didrickson Dettweiler*							Out	2893	34		37			
							Total	5418	67		73			

BABE'S BEST. Pushed back a day due to heavy rains in Aiken, the inaugural Women's Invitational golf tournament got underway on March 13, 1937 at Highland Park Golf Club. Mildred "Babe" Didrickson set the pace over a soggy 5,418-yard layout to take medalist honors in qualifying with a 73. Helen Dettweiler attested to Didrickson's score of 37 going out and 36 over the closing nine holes. Patty Berg won the match play event for the week, besting Augustan Barbara Bourne for the title. (Courtesy Aiken County Historical Museum.)

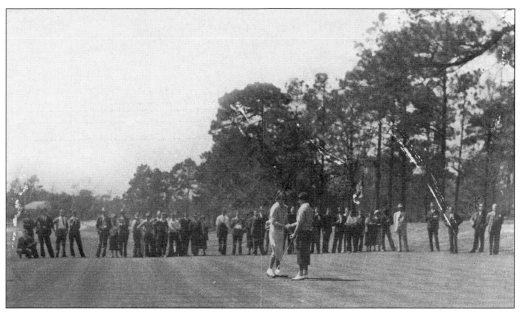

PATTY'S PARTY. Patty Berg defeats Augustan Barbara Bourne 6 and 4 in the finals of match play in the 1937 Women's Invitational at Highland Park Golf Course in Aiken. Bourne gained attention by posting an upset win against the highly favored Babe Didrickson, who took medalist honors in the qualifying round. The daughter of Augusta benefactor Alfred S. Bourne, Barbara later married golfer Horton Smith, the first winner of the Masters Tournament. (Courtesy Aiken County Historical Museum.)

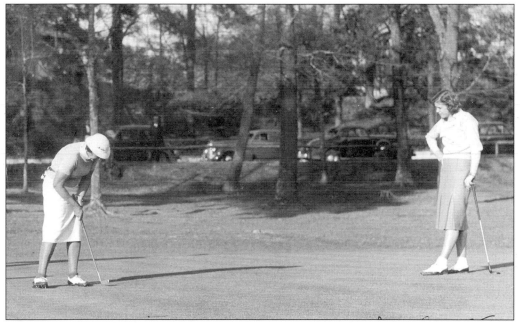

AUTO-MATIC. Opal Hill of Kansas City and Jane Crum of the University of South Carolina compete in the Women's Invitational at Highland Park Golf Club. Note the close proximity of the cars in the background, which reportedly could follow tournament play from nearby roadways. (Courtesy Aiken County Historical Museum.)

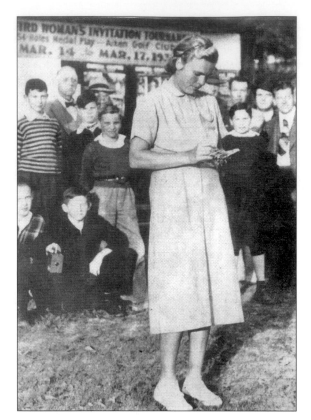

SIGN OF THE TIMES. Helen Detweiller checks her scorecard in the 1938 women's golf event in front of the sign touting the Women's Invitation Tournament at Highland Park Golf Club. Dettweiler, of Washington, D.C., teamed up with Katheryn Hemphill of Columbia, South Carolina to capture both the team best-ball and match-play competitions staged that year. Patty Berg made headlines early in the week when she posted a new women's course record of 69 during a practice round for the event. The following week, Dettweiller won the Augusta Women's Invitational at Forest Hills. (Courtesy Lista's Studio of Photography.)

FOUR FOR FORE. Joe Frasca collected $4 from a twosome that included entertainer Fred Astaire for a round of golf at the Aiken Golf Club on November 11, 1940. Five years later, Frasca assumed duties at the Augusta Country Club. Jim McNair Sr. took over as head professional at the Aiken Golf Club in 1958 with son Jim Jr. succeeding him in 1987. The elder McNair was unbeaten for two seasons in match play as the number one player at Duke University and was later inducted into the South Carolina Golf Hall of Fame. (Courtesy Lista's Studio of Photography.)

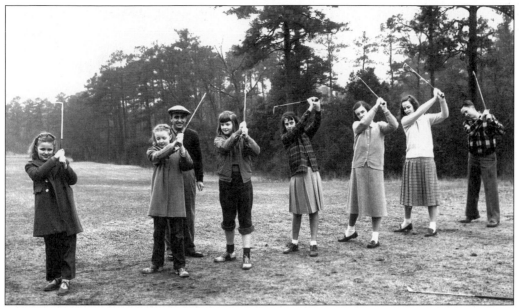

FRASCA'S FOLLOW THROUGH, c. 1945. When the city of Aiken purchased the Aiken Golf Club in 1939, federal grants and city funds of nearly $12,000 were utilized to update the course. The city also promoted Joe Frasca to head professional. Here Frasca holds a clinic for a group of well-dressed juniors at the club. (Courtesy Aiken County Historical Museum.)

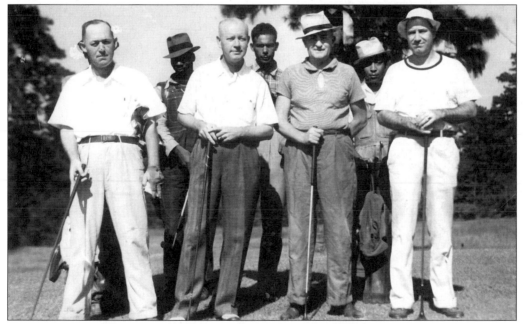

DRESSED TO THE NINES, OCTOBER 3, 1939. This image is from the personal scrapbook of Joe Frasca, Aiken Golf Club head professional from 1939 through 1945, which is on display at the Aiken County Historical Museum. Frasca liked to keep a reminder on hand for golfers using the facility of "how the well dressed golfer should not be dressed." In 1945, Frasca left Aiken to assume similar duties at the Augusta Country Club, where he succeeded David Ogilvie, who had logged 46 years of service with the club. (Courtesy Aiken County Historical Museum.)

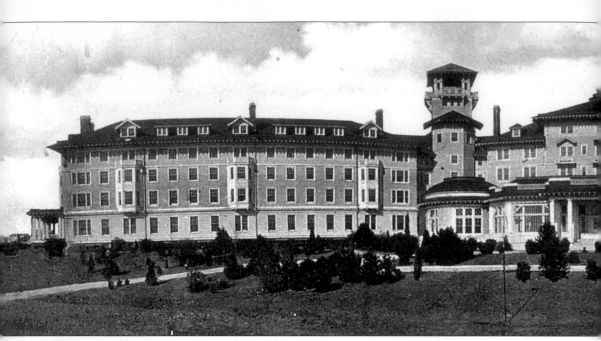

HAMPTON HUGE, C. 1910. Just across the river from Augusta in neighboring North Augusta, South Carolina, city founder James U. Jackson saw the vision of opportunity that tourism afforded. In April 1902 he broke ground on a five-story, 300-room structure that spanned the length of over two football fields. When it opened in early 1903 the Hampton Terrace Hotel was reported to be the largest wooden structure in the world. Sitting 350 feet above the level of

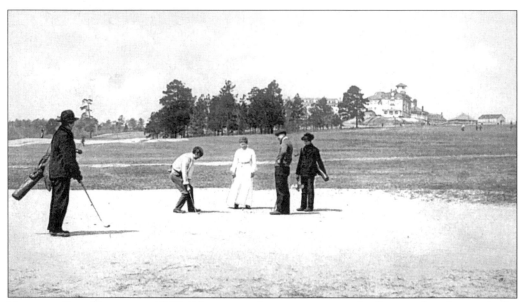

NUMBER ONE GREEN, C. 1905. This image shows putting on the first sand surface with the Hampton Terrace in the background. The first two holes of the golf course were downhill par 5s. The hotel was erected in less than a year and opened in early 1903. Membership to the Hampton Terrace Golf Club was open to the public at a cost of $20 per year for men and $10 per year for women, with no initiation fee. (Courtesy Joseph M. Lee III.)

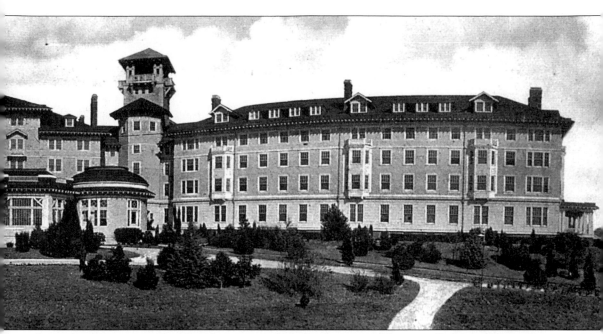

downtown Augusta, sights 50 miles away in Lincoln County could reportedly be seen from the top floors of the five-story structure, as well as the city of Aiken, which was 18 miles to the east. The "Grand New Hotel" was proclaimed "One of the Very Finest in the Country," in bold print in *The Augusta Chronicle* of January 15, 1903. (Courtesy Joseph M. Lee III.)

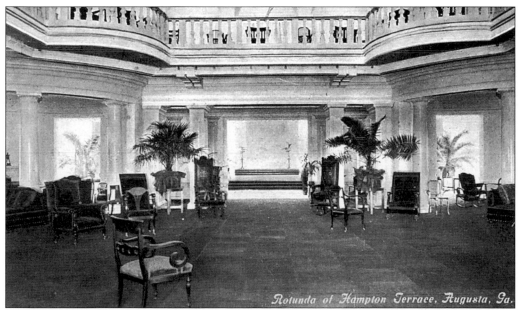

ROTUNDA, C. 1905. An article in the January 16, 1903 edition of *The Augusta Chronicle* detailing the new Hampton Terrace offered that "the glass ceiling of the rotunda is laid at the level of the fifth floor," and that around the openings to the other three floors "will be placed plush-covered balusters and cap with seats arranged next to them," allowing guests the sights and sounds of music and dance on the rotunda floor. (Courtesy Joseph M. Lee III.)

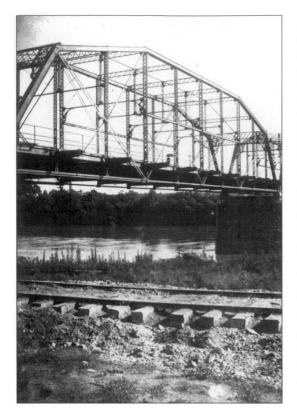

BRIDGING THE GAP, C. 1897. In 1891, city founder James U. Jackson acquired capital to form the North Augusta Land Company. The company bought thousands of acres of land for development on the South Carolina side of Augusta, then built this steel bridge at a cost of $85,000 to span the Savannah River at the present-day Thirteenth Street. In 1902, Jackson added a trolley line across the bridge, then extended it to Aiken. A line was also extended to include Augusta's tourist-laden Union Station. The Augusta-Aiken Trolley was the first electric trolley in the South and continued operations until 1929. This link connected the resort areas of Augusta with the Hampton Terrace and the city of Aiken, 18 miles to the east. The steel bridge was torn down in 1938 to allow for construction of the present bridge that spans the Savannah River at Thirteenth Street. (Courtesy Augusta-Richmond County Historical Society, Reese Library, Augusta State University.)

OF HAWKS AND HAMPTON, C. 1906. The Hampton Terrace paints the background of the view from "Hawk's Gull" near Broad Street and Fifteenth Street looking towards North Augusta. Riverwatch Parkway now spans the gully just north of the since-torn-down railroad bridge in this picture. (Courtesy Milledge G. Murray Collection.)

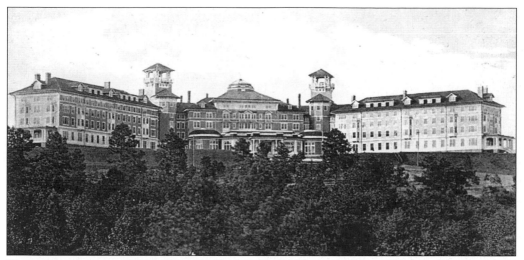

HAMPTON HIGH, C. 1905. From 1903 through 1916, the Hampton Terrace Hotel cast an imposing sight from the highest hill in North Augusta. Coupled with the Hotel Bon Air on the Georgia side of the Savannah River, the hotels resembled majestic bookends overlooking downtown Augusta. Booked solid for the 1917 season that would begin just four days later, this magnificent grand hotel burned to the ground in just five hours in the early morning hours of New Years Eve, 1916. The Hampton Terrace was open each year from January to May. (Courtesy Joseph M. Lee III.)

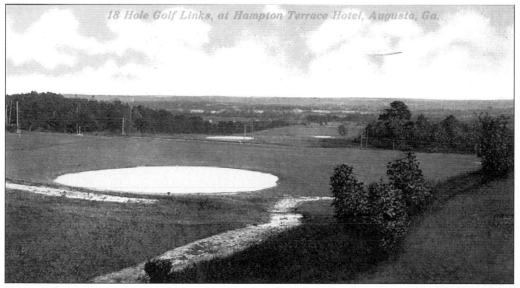

EYEING AUGUSTA, C. 1910. Note the three sand surfaces in this view of Hampton Terrace Golf Course looking away from the Hampton Terrace. The downhill, 593-yard, par-5 second hole at Hampton Terrace Golf Club was likely one of the longest in existence at the turn of the century. Allowing for present-day advancements in technology, an equivalent golf hole today would likely measure 800 yards in length, according to South Carolina Golf Hall of Fame member Bobby Knowles. An average drive in the early 1900s would have been between 175 and 200 yards. Breaking 20 over the first four holes at Hampton Terrace, three of which were par 5s, was considered a good score. The design was a par 72 and measured 5,901 yards. (Courtesy Joseph M. Lee III.)

LADY IN WAITING, C. 1910. This rare view of the foyer entrance shows the elegance of the Hampton Terrace Hotel. A large, glass-enclosed piazza located away from the suites was a special treat to guests of the Hampton Terrace Hotel, as the area could be utilized for parties and dances without disrupting guests who retired early for the evening. The Hampton Terrace grew so popular that for the first time ever in 1909, people seeking to stay at the luxurious hotel were turned away due to a lack of accommodations. (Courtesy Augusta Museum of History.)

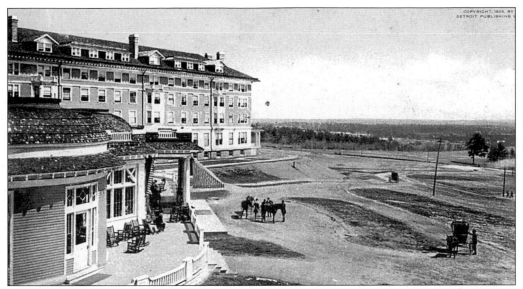

EAST WING AND GROUNDS, C. 1905. This is an early 1900s view of the Hampton Terrace's East Wing. Note the far right and middle of the picture, where it appears golfers may be teeing off from the first tee. The course's 508-yard first hole was a downhill par 5. Three of the course's first four holes were par 5s that took golfers from the top of the hill in North Augusta on a quick descent to two blocks east of the present-day City Hall-Public Safety Building. (Courtesy Joseph M. Lee III.)

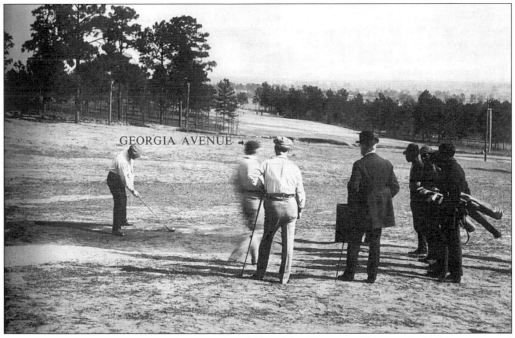

GEORGIA AVENUE? C. 1905. The par-5 first hole of the Hampton Terrace Golf Course crossed over Georgia Avenue in back of the trees pictured to the left in the photo. The golf course was a 9-hole layout when this photo was taken, and expanded to 18 holes for the 1909 season. (Courtesy Heritage Council of North Augusta.)

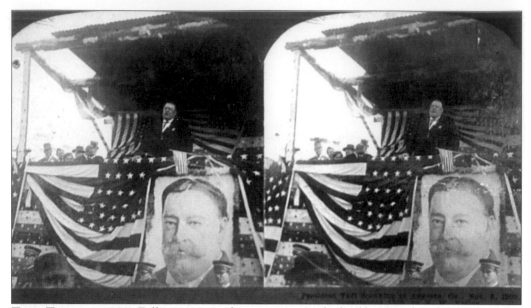

TAFT TALK, C. 1909. Following an early morning round of golf on Wednesday, January 20, 1909, President-elect William Howard Taft was escorted from his winter vacation home on Milledge Road to downtown Augusta, where he made a 20-minute public address at Broad and Jackson Streets. According to accounts in *The Augusta Chronicle* on Thursday, January 21, 1909, some 10,000 people were on hand, described as "one of the largest crowds that has ever assembled in Augusta." During his address, Taft made mentioned that he had not missed a day of golf while vacationing in Augusta for more than a month. The President-elect went on to say that he had chosen his cabinet members during the stay. Sharing headlines in *The Augusta Chronicle* with Taft's visit that day was the Senate's approval of a pay raise for U.S. Presidents to $100,000, which would also include all travel costs.

That evening, Taft was feted by the Chamber of Commerce of Augusta at a banquet in his honor at the Hampton Terrace. According to a report by *The Augusta Chronicle*, it was "one of the most elegant functions ever presented in the South." Taft's table was treated to water from an historic glass decanter that President George Washington used in 1791. While festivities began at 8:30 p.m. at the hotel, the banquet was so grand in design that it was past one in the morning before Taft was introduced to the assembly. The bulk of the President-elect's speech centered on the Panama Canal, but Taft also remarked on his personal-best 88, fired on the golf links at the Country Club of Augusta's Lake Course, joking that there was "a suggestion that my head had swelled by today's score. That is so." Taft went on to say "I am not quite certain today whether I would rather have done that or have been elected president of the United States." (Courtesy Augusta Museum of History.)

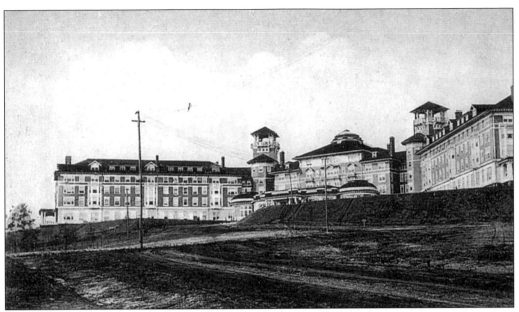

FIRE PROTECTION, C. 1910. For a hotel that prided itself in catering to every small detail, it would prove odd that several glaring oversights would ultimately hasten the Hampton Terrace's demise. When firefighters from Augusta arrived on the scene in the wee hours of that fateful New Years Eve in 1916, they found fire hydrants located on the hotel's steep side inaccessible to pumper trucks, low water pressure, and hydrants that had not been fitted with standard connections.

A newspaper article in January 1903 addressed the issue of fire protection at the Hampton Terrace. The report in *The Augusta Chronicle* stated that "in many large hotel fires . . . when the conflagration starts in the lower part of the building, elevator wells not only serve as chimneys to increase the draft and fury of the flames, but carry them quickly from story to story until the whole structure is ignited." To alleviate this concern at the Hampton Terrace, "the elevator shafts are built of solid brick . . . [with] little, if any, likelihood of carrying the conflagration to other stories." The Hampton Terrace also contained an automatic fire alarm system that could also reportedly locate a fire, and it was equipped with a half-dozen fire escapes and escape ropes in every rooms. "Five or six years ago most of North Augusta was one large sand pit," reports the *Augusta Chronicle* on Friday, January 5, 1909. The article was entitled "North Augusta Growing More Popular Every Day," and added in bold print, "People in Prosperous Suburb Enjoying Many Privileges" of the clean and modern city, which also assured of ample fire protection. (Courtesy Joseph M. Lee III.)

WEST WING, C. 1916. This view shows the far west wing of the hotel, where fire broke out on New Year's Eve, 1916. The cause of the blaze was blamed on faulty wiring in walls near the ceiling on the third floor. The fire reportedly could be seen as far away as Athens, Georgia, 90 miles to the west, and on the day after the blaze, thousands from the surrounding area made the trip to North Augusta to view the ruins. With a bridge spanning the Savannah River and a trolley system in place, North Augusta survived the blaze. (Courtesy Joseph M. Lee III.)

THE WAY IT WAS. When this postcard was mailed on January 30, 1917, the Hampton Terrace had lain in ashes for 30 days. Note the postmark "The Hill Station," as the sender likely vacationed at either the Bon Air Hotel, which housed a post office facility, or the nearby Partridge Inn. Five years later, the Bon Air would suffer the same fate as the Hampton Terrace. (Courtesy Joseph M. Lee III.)

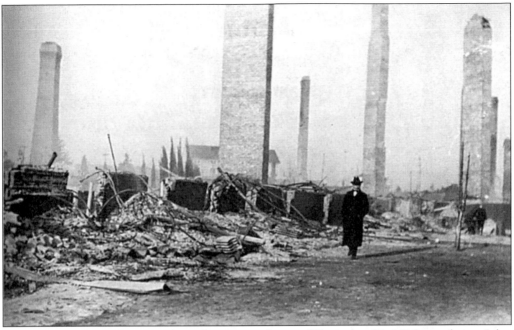

THEN THERE WAS NONE. In the early morning hours of December 31, 1916, watchman John O'Keefe discovered fire on the fifth floor of the west wing and immediately sounded the alarm. However, according to reports in the next morning's edition of *The Augusta Chronicle*, "it was evident that fire had been eating its way through the west wing some time before O'Keefe located it." It was also reported that the blaze started in Room 7 of the far west wing "and at one time it seemed that the fire was under control." "About 3 a.m. flames burst out through the west wing, and an 'all persons out' order was given by firemen, it being then evident that the magnificent hostelry was doomed." While firemen were hampered by low water pressure and fire plugs without standard fittings, they did manage to get several streams of water on the fire. By then, however, the fire was raging and attention shifted to protecting nearby residences.

Accounts of the Hampton Terrace fire in the next day's paper bordered between dramatic and heroic. Luckily, no one was seriously injured in the fire. The newspaper reported that about 100 staff members were asleep in the hotel when fire broke out. "When the flames burst out showing that the west wing was gone, the scene was a dramatic one. People had gathered by the hundreds. Volunteers jumped in to assist the firemen. . . . Young women were gotten out just in time. . . . In instances they had to be pulled from their rooms and were carried away screaming. . . . Men took great risks in searching the wing." "The firemen fought with all the fight that was in them. The water facilities were absolutely inadequate. The opportunities to fight the fire were small. The heat was intense. The excitement was of the wildest. The cry to save human life was heard above the din. But the firemen and the citizens never game up for a moment." "When the fire . . . suddenly burst out in the [west] wing . . . the sky was illuminated almost like a flash and there was a silence among the spectators for a moment. Every one at that time came to the conclusion that the entire structure must go."

In the photo above, Hampton Terrace founder James U. Jackson surveys the hotel ruins after the fire. (Courtesy Heritage Council of North Augusta.)

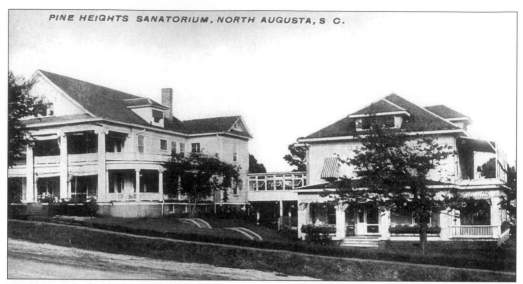

PINE HEIGHTS SANATORIUM, NORTH AUGUSTA, S C.

HEIGHTS HISTORY, C. 1903. The Pine Heights Sanatorium on Georgia Avenue was built just prior to the Hampton Terrace and served as the area's medical-surgical facility. According to research by Pine Heights's current owner, Dr. Joe Holt, the structure housed a clinic for Professor Doughty, who was the chief surgeon and dean of MCG medical school at the turn of the century. When the hospital did not have full occupancy, it rented rooms to vacationers and when Ty Cobb was player-manager of the Detroit Tigers in 1922 and 1923, the facility was utilized as the team's spring training headquarters. The ballplayers stayed at nearby Lookaway and Rosemary Halls, located on opposite sides of Carolina and Forrest Avenues. The building on the right was destroyed by fire in 1983. Pine Heights today serves a function close to its original purpose, as medical offices. (Courtesy Dr. Joe Holt.)

PAGES FROM THE PAST. Tattered shreds of paper are all that remain of the original Hampton Terrace register, which survived the hotel fire in 1916 and lay buried in sacks for three quarters of a century in the basement of nearby Pine Heights. This Who's Who of American Society was unearthed by the property's new owner, Dr. Joe Holt, in 1993. (Photo by Stan Byrdy. Courtesy Dr. Joe Holt.)

KENNEDY CONNECTION. This page from the register contains the badly faded, barely legible signature of John Fitzgerald of Waterbury, Massachusetts, believed to be the grandfather of the 35th President of the United States, John Fitzgerald Kennedy, and the father of Rose Kennedy. Known affectionately as "Honey Fitz," he was the esteemed mayor of Boston. Fitzgerald's signature appears fifth from the bottom in the photo. (Photo by Stan Byrdy; Courtesy Dr. Joe Holt.)

SIGN PLEASE, ROBERT E. LEE. Confederate General Robert E. Lee's son, a medical doctor from Washington, D.C., signed the Hampton Terrace ledger on Monday, July 15, 1907. These photos are the first ever published from the 95-year-old register, which contains the rare signatures of hundreds of prominent Americans who stayed at the historic hotel during July 1907. (Photo by Stan Byrdy; Courtesy Dr. Joe Holt.)

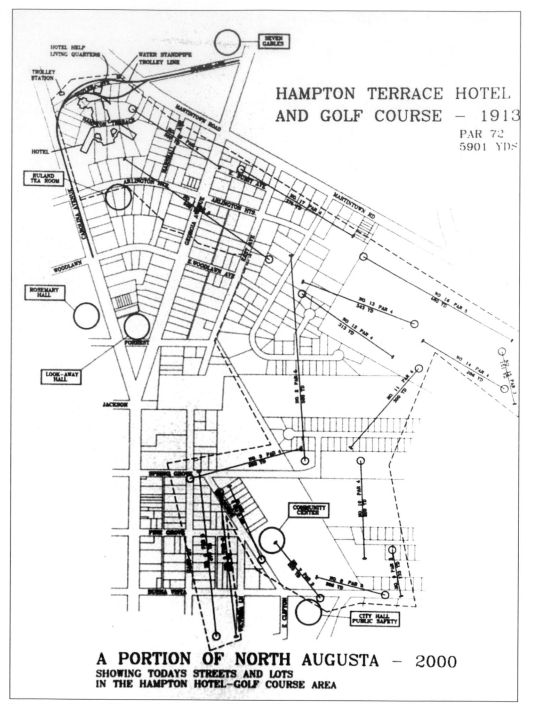

HAMPTON TERRACE HOTEL
AND GOLF COURSE – 1913

PAR 72
5901 YDS

A PORTION OF NORTH AUGUSTA – 2000
SHOWING TODAYS STREETS AND LOTS
IN THE HAMPTON HOTEL–GOLF COURSE AREA

THEN AND NOW. This map shows the Hampton Terrace Golf Course as it appeared in 1913. The 5,901-yard, par-72 test played like a roller-coaster, with three of its first four holes downhill par 5s. The final three holes wound back uphill from the site of the present-day North Augusta Plaza. (Photo by Stan Byrdy; Courtesy Heritage Council of North Augusta.)

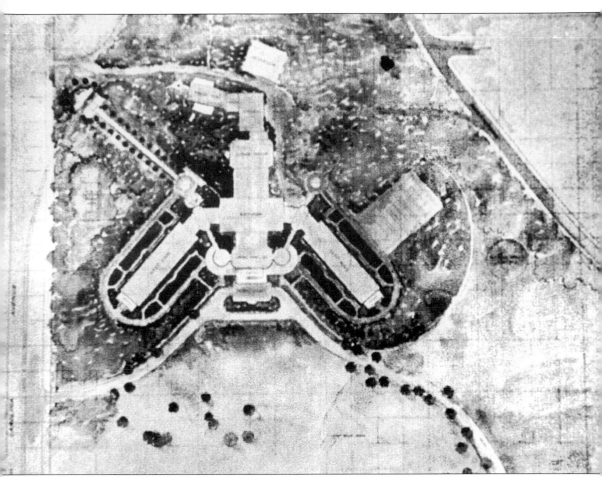

BIRD'S EYE VIEW. This is an architect's rendering from high above the mighty Hampton Terrace prior to construction in 1902. Vast facilities to the rear of the structure housed a 60-by-90 foot main dining area with a 25-foot ceiling, and kitchen facilities featuring an automatic dishwasher. The hotel also had a sub-pavement restaurant that guests could access late at night. Unveiled during the winter of 1909 was a track running from the nearby trolley line directly to the hotel door. The first tee of the golf course was located to the front of the building, just below the terrace. By 1909, the golf course was expanded from 9 to 18 holes, with the finishing 3 holes climbing uphill along Martintown Road to the Hampton Terrace. An avid golfer, President-elect William Howard Taft was honored at a banquet at the Hampton Terrace on January 20, 1909, and was also said to have been impressed with its golf course. (Courtesy Frances Loeb Library, Graduate School of Design, Harvard University.)

SIXTH HOLE STOP SIGN. The putting green for the par-4 sixth hole at Hampton Terrace was in the middle of Brookside Drive, just in back of the stop sign posted at the present-day driveway of the North Augusta Community Center. (Photo by Stan Byrdy; Courtesy City of North Augusta.)

LONG WAY HOME. Parts of six holes were located in what is now the North Augusta Plaza. The Hampton Terrace's final three holes all ran uphill and were parallel with Martintown Road. The tee for the 480-yard, par-5 16th hole was positioned at the far end of the plaza. Play continued to the top of the hill, and the 18th green was situated within 100 feet of the grand hotel. (Photo by Stan Byrdy; Courtesy Heritage Council of North Augusta.)

HAMPTON TERRACE SMOKESTACK. This pile of bricks, in the backyard of a residence at Hampton Terrace and Butler Avenue, was part of the hotel's great smokestack, which was reported to be nearly the size of the old Confederate Powderworks chimney in Augusta. In the early 1900s, movie executives eyed North Augusta as the new film capital of the world. Its warm winter climate, abundance of rooms, and accessibility by train were appealing to filmmakers. Local developers, however, were wary of being associated with the industry; in the end, Hollywood won out. (Photo by Stan Byrdy; Courtesy Heritage Council of North Augusta.)

MARKING THE SPOT. The Hampton Terrace's far west wing sat on the hill, which today overlooks this marker just off Carolina Avenue, between Arlington Heights and Butler Avenue. All that remains of the hotel today is this sidewalk and rubble from the hotel's smokestack. Fifteen lots on Hampton Terrace now occupy the space of the once-mighty hotel. (Photo by Stan Byrdy; Courtesy Heritage Council of North Augusta.)

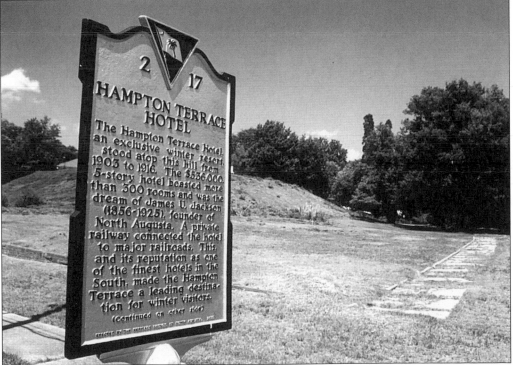

2 17

HAMPTON TERRACE HOTEL

The Hampton Terrace Hotel, an exclusive winter resort, stood atop this hill from 1903 to 1916. The $536,000, 5-story hotel boasted more than 300 rooms and was the dream of James U. Jackson (1856-1925), founder of North Augusta. A private railway connected the hotel to major railroads. This and its reputation as one of the finest hotels in the South, made the Hampton Terrace a leading destination for winter visitors.
(Continued on other side)

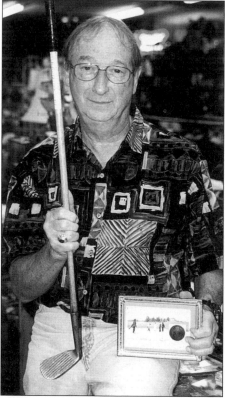

RULAND'S TEA ROOM. Located just below the site of the hotel, this structure went from being a tea room to a tee room overnight. On New Year's Day 1917, an article in *The Augusta Chronicle* reported, "Tea Room May Remain Open For Golf Players" and went on to say "on account of the Hampton Terrace's golf links being the among the best in the South, many tourists from other hotels in this section will likely use the links and also patronize her Tea Room." (Photo by Stan Byrdy; Courtesy Heritage Council of North Augusta.)

GHINGOLD'S GOLD. Augusta antique dealer Neil Ghingold holds rare artifacts from the Hampton Terrace Golf Club. The hickory-shafted, deep-groove iron is inscribed with the name J.R. Inglis and the words "Hampton Terrace" on the back. Inglis was Hampton Terrace's head golf professional and later leased the Highland Park Golf Club in Aiken until the city bought the facility in 1939. The framed postcard of golfers putting on the first green is accompanied by the Hampton Terrace's "Caddy Badge #1," which was unearthed as land was cleared for the Georgia Golf Hall of Fame on Reynolds Street. (Photo by Stan Byrdy; Courtesy Neil Ghingold.)

Three

THE LEGEND OF FOREST HILLS

When Bobby Jones won the Grand Slam in 1930, his quest began in Augusta at the Southeastern Open, a 72-hole event staged over two days. Hosted jointly by the Augusta Country Club and Forrest Hills Golf Course, the tournament included a top field of international stars, including five future Masters champions. Jones would later say it was the best tournament he ever played, and it provided the momentum to attain golf's greatest feat. Originally spelled with two Rs after investor Forrest Adair, Forrest Hills later dropped an R to become Forest Hills Golf Club. Constructed in 1926, the tattered old clubhouse and 13 holes from the original golf course still remain.

Army camp turned winter resort, then wartime army hospital, and later VA medical center, Forest Hills has worn each tag honorably. Golf course abandoned, reclaimed, and restored as a state university interest, the resilient Forest Hills is the soul of golf in Augusta, serving faithfully in times of war and peace as perhaps no other facility in American history.

Across Wrightsboro Road from Forest Hills is the Augusta Municipal Golf Course, Augusta's first public course. Designed in 1928, "The Cabbage Patch" turns 75 in 2003. Lawson E. "Red" Douglas Memorial Clubhouse stands as a testament to 45 years of dedicated service to public golf that Douglas provided while head professional at The Patch from 1946 until his death in September 1991. Located between the Augusta Golf Club and Forest Hills is the third link in Augusta's commitment to public golf, The First Tee, which affords the game to youth.

FISTS OF FURY, C. 1917. Forest Hills began life during World War I as Camp Hancock. This friendly match of fisticuffs symbolizes the fight in Forest Hills to maintain its identity during dramatic changes in the past century. (Courtesy Milledge G. Murray Collection.)

TENT CITY, C. 1917. Named in honor of Union General Winfield Scott Hancock, Camp Hancock housed military troops during World War I and covered much of what is now Forest Hills Golf Club. Ironically, it was President Woodrow Wilson's declaration of war against Germany that led to the building of the camp, located in the shadows of his boyhood home in downtown Augusta. By October 1918, over 35,000 army and national guard troops were stationed at Camp Hancock. (Courtesy Milledge G. Murray Collection.)

THE LINE FORMS HERE, C. 1917. The chow line forms at Camp Hancock during World War I. The line of golf champions that have played at Forest Hills is also long and illustrious, from Bobby Jones in the 1930 Southeastern Open to Phil Mickleson in 1989 and Justin Leonard in 1992 in the Forest Hills College Invitational. Golfers hungry to prove themselves, including Augustan Charles Howell III, have honed their skills on Forest Hills's championship layout. (Courtesy Milledge G. Murray Collection.)

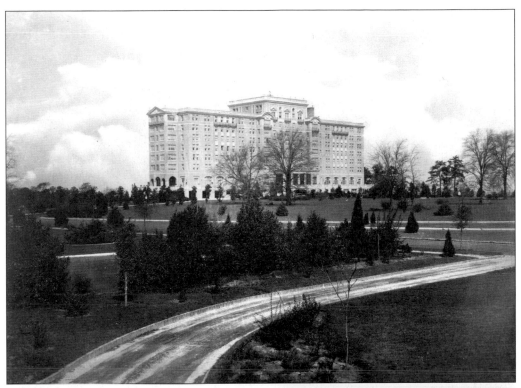

WINDING ROAD C. 1926. Constructed on a 600-acre park, the fireproof Forrest Hills-Ricker Hotel offered scenic views of the two-state area and included large ballroom and dining areas and four large sun parlors. With accommodations for 400 guests, the Ricker Hotel also afforded a telegraph office, beauty salon, barber shop, and free golf to all weekly guests. (Courtesy Forest Hills Golf Club.)

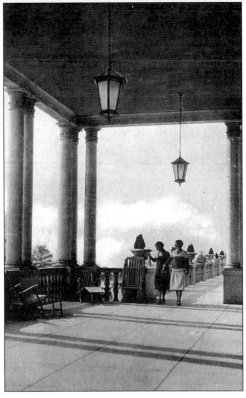

SPACIOUS C. 1930. Shown here is one of the large porches that surrounded the Forrest Hills-Ricker Hotel, where striking views of the Georgia and South Carolina countryside could be seen. Hailed as the "Best All-Winter Resort in the South," Augusta was less than one day's travel time from New York and Washington, D.C. by train. (Courtesy Joseph M. Lee III.)

HILLS HOUSE, C. 1935. Pictured is the original clubhouse at Forrest Hills as it appeared when it hosted the 1930 Southeastern Open. During the off-season following the tournament, the course was open to the public for a greens fee of 75¢. (Courtesy Augusta Museum of History.)

IN THE BLACK, C. 1929. Expenses for the Forrest Hills Golf Shop for the five-week period from April 17 to May 24, 1929 totaled $224.76, with $443 in deposits, leaving a balance of $218.24 at Union Savings Bank. The following April, the final two rounds of the Southeastern Open were staged at Forrest Hills. (Photo by Stan Byrdy; Courtesy Forest Hills Golf Club.)

**BOBBY C. AND BOBBY DO, C.
1930.** While Bobby Jones won
the Southeastern Open by 13
shots in 1930, Bobby
Cruickshank of Scotland may
well have profited most from the
runaway victory. Losing to Jones
in a playoff for the 1923 U.S.
Open, Cruickshank had seen
enough after the Southeastern
Open in Augusta. Convinced
that Jones would win the Grand
Slam, Cruickshank wagered $500
with a bookmaker in Great
Britain, at 120-1 odds. Later that
summer, Cruickshank pocketed
$60,000. This photograph of
Bobby Jones is believed to have
been taken at Forrest Hills Golf
Club during the Southeastern
Open in 1930. (Courtesy Ross
Snellings Collection.)

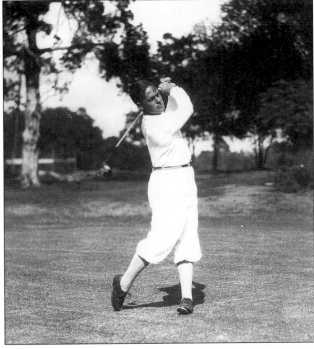

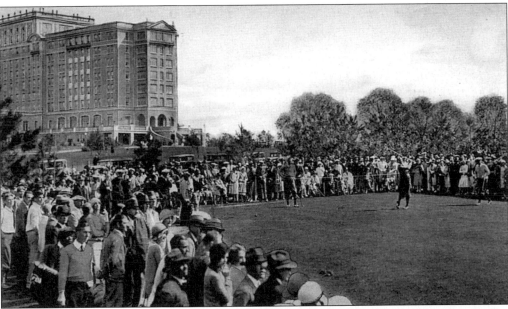

FIRST AT FOREST HILLS, C. 1930. Ed Dudley tees off in front of a large gallery at the
Southeastern Open in 1930. Hand-picked by Bobby Jones to be the first head professional at
the Augusta National Golf Club, Dudley set a course record 68 in the morning round at Forrest
Hills on April 1, 1930. The purse for the Southeastern Open in 1930 totaled $5,000 and
was one of the highest paying events of its time. While Bobby Jones won the tournament by
13 shots as an amateur, Horton Smith won the first-place prize money of $1,000, and Dudley
finished in third place, good for $750. Smith later won two of the first three Masters
Tournaments. (Courtesy Joseph M. Lee III.)

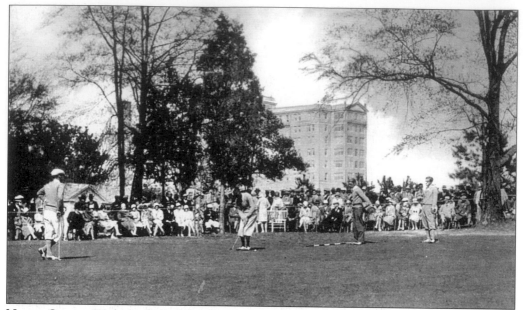

NINTH GREEN. With the Ricker Hotel serving as a backdrop, the gallery watches action on the 9th green in the Southeastern Open at Forrest Hills. The tournament was staged in Augusta in 1930 and 1931. In 1936 and 1938 the name was changed to the Augusta Open. (Courtesy Joseph M. Lee III.)

DUDLEY DO RIGHT, C. 1921. Ed Dudley of Wilmington, Delaware set a course record 68 at Forrest Hills Golf Course in the 1930 Southeastern Open. Dudley teed off at 7:30 that morning for the first of 36 holes with Horton Smith. Dudley finished one shot in back of Smith, and the duo pocketed $1,750 of the $5,000 total prize money for finishing in the top two paying spots behind amateur Bobby Jones. (Courtesy Scott Nixon Collection, Augusta Museum of History.)

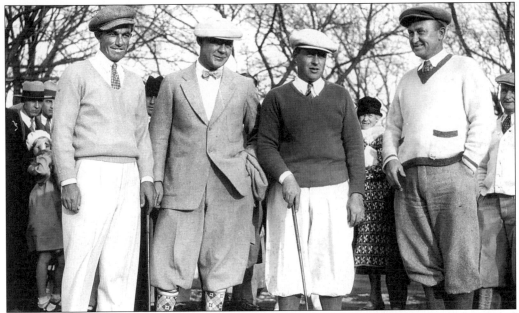

FAMOUS FOURSOME. The 1928 U.S. Open champion Johnny Farrell (who won in a playoff with Bobby Jones), sportswriter Grantland Rice, Bobby Jones, and Baseball Hall of Famer Ty Cobb pose on the 18th green at Forrest Hills on March 30, 1930, following a practice round for the Southeastern Open. After watching Jones dominate in the 1930 Southeastern Open, Cobb was quoted as saying, "There is no way to estimate the genius of Bobby Jones . . . He is the greatest competitive athlete I have ever seen." This, coming from a sports legend who amassed a .367 lifetime batting average over 24 seasons in the major leagues, was quite a compliment. (Courtesy Forest Hills Golf Club.)

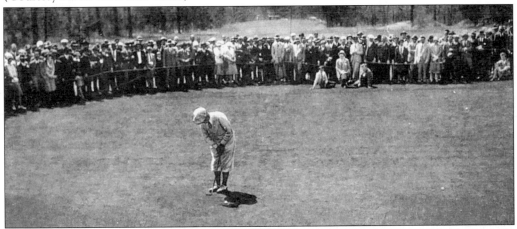

FORREST FOURTH, C. 1930. A gallery of patrons surrounds the putting green of the fourth hole at Forrest Hills, a 177-yard, uphill par-3. This hole, played by Bobby Jones during the 1930 Southeastern Open, no longer exists, although the present-day fourth hole remains an uphill par 3. The Southeastern Open in 1930 was played out in just two days, the first 36 holes taking place on Monday, March 31st at the Augusta Country Club's Hill Course, with the finishing two rounds at Forrest Hills the following day. Bobby Jones and Horton Smith were a popular pairing for the first two rounds. The headline greeting patrons of *The Augusta Chronicle* on April 2nd proclaimed, "Bobby Jones Is Victor" in large bold type. (Courtesy Joseph M. Lee III.)

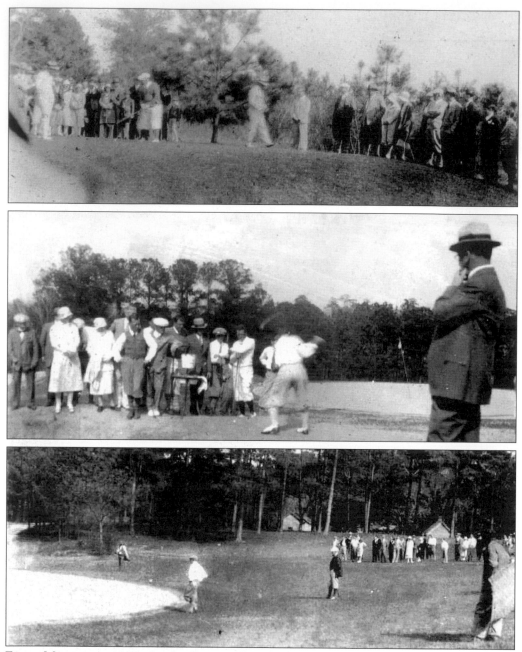

FIFTH MAJOR, C. 1930. In the historic Grand Slam year of 1930, Bobby Jones won five tournaments, including the Southeastern Open at Augusta Country Club and Forrest Hills, the biggest golf event staged in the South at that time. Jones beat five future Masters champions—Gene Sarazen, Horton Smith, Craig Wood, Henry Picard, and Ralph Guldahl—and a host of top American and international stars, including Walter Hagen, Bobby Cruickshank, Harry Cooper, Johnny Farrell, Paul Runyan, and Denny Shute, to win the tournament. The above photographs were taken by Scott Nixon during the final two rounds at Forrest Hills Golf Course. The picture on top was labeled "Bobby Jones at Forrest Hills, April 1930" in Nixon's personal photo album. (Photos by Scott Nixon; Courtesy Augusta Museum of History.)

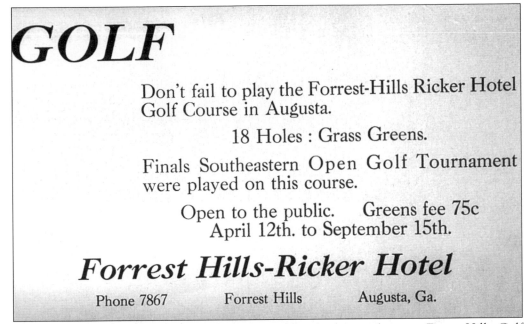

GOLF

Don't fail to play the Forrest-Hills Ricker Hotel Golf Course in Augusta.

18 Holes : Grass Greens.

Finals Southeastern Open Golf Tournament were played on this course.

Open to the public. Greens fee 75c
April 12th. to September 15th.

Forrest Hills-Ricker Hotel

Phone 7867 Forrest Hills Augusta, Ga.

FORREST FEES, C. 1930. This advertisement is on display at the new Forest Hills Golf Clubhouse. Following Bobby Jones's win in the 1930 Southeastern Open, the course was open to the public during the off-season from mid-April to mid-September, with a greens fee of 75¢. (Courtesy Forest Hills Golf Club.)

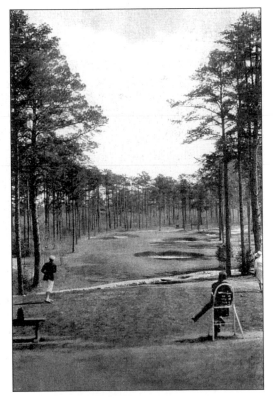

TEE TO GREEN, C. 1931. Postmarked February 26, 1931 on the back, this postcard shows a twosome and caddie on the tee of the 192-yard, par-3 16th hole at Forrest Hills. Sportswriter O.B. Keeler noted "Number 16 is my nomination for the finest hole on the course." Golf legend Bobby Jones would come to know the hole as the "giant killer" as he carded a six here during the closing round of the 1930 Southeastern Open. Jones hit his drive into the edge of the woods to the left of the bunker guarding the green, then knocked his second shot just over the hazard and watched as it rolled back into the sand. From there, he blasted out to 40 feet away and three-putted. Jones also scored a six on the final hole, yet won the tournament by 13 shots. (Courtesy Joseph M. Lee III.)

91

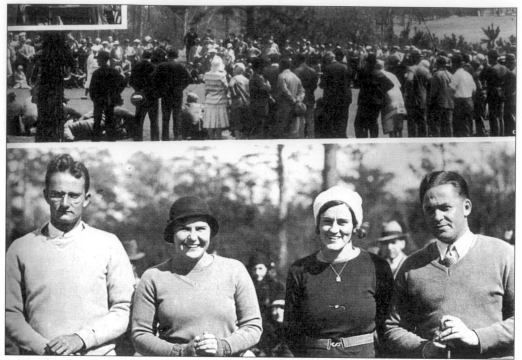

AUGUSTA OPEN, C. 1936. Pictured at Forest Hills during a charity match prior to the 1936 Augusta Open are, from left to right, Eugene Homans, Helen Hicks, Maureen Orcutt, and Robert Tyre Jones Jr. The 1928 U.S. Open Champion, Johnny Farrell, won the tournament that year. (Courtesy Milledge G. Murray Collection.)

POSTAL PRIDE C. 1938. This commemorative air-mail letter, sent in 1938, rightfully acknowledges Augusta as "The Winter Golf Capital of America." The Augusta-Aiken area hosted no less than seven large-scale golf tournaments, including three major championships in 1938: the Masters Tournament and PGA Seniors Championship at the Augusta National, the Titleholders Championship at the Augusta Country Club, the Augusta Open at the Augusta Country Club and Forest Hills, the Augusta Women's Invitational at Forest Hills, the Women's Invitational at Highland Park, and the Southern Cross at Palmetto Golf Club. (Courtesy Bill Baab Collection.)

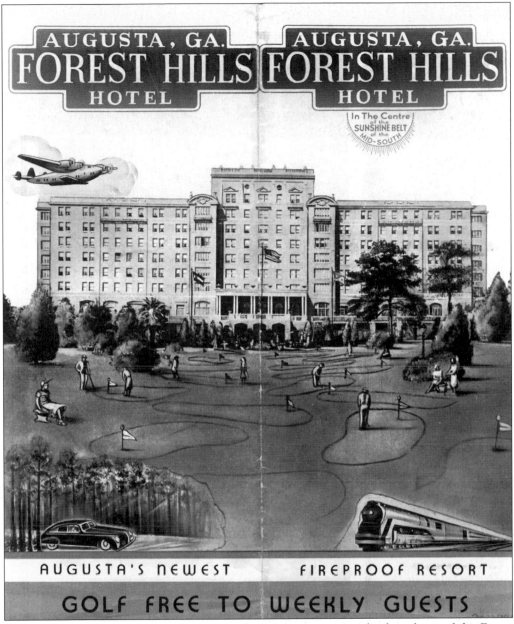

FOREST HILLS-RICKER AD C. 1940. Note the putting greens on the front lawn of the Forest Hills-Ricker Hotel, which were introduced in 1935. Also note the spelling change from two Rs to one R in Forest Hills. It is believed this change occurred in the mid-1930s. (Courtesy Augusta Museum of History.)

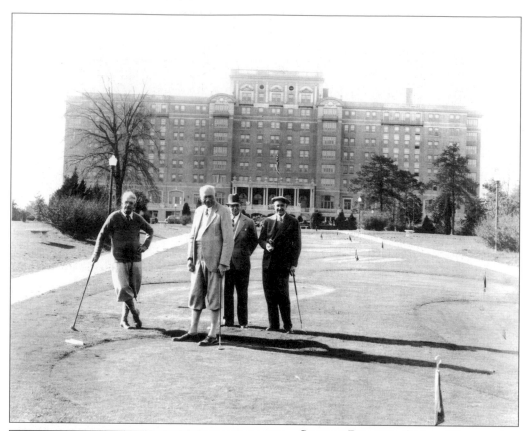

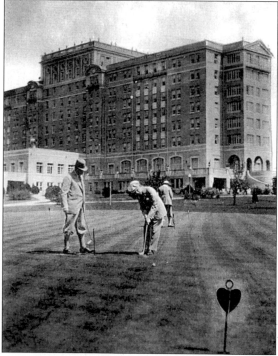

SCOTCH PUTTING GREEN. The scotch putting course opens on the front lawn of Forrest Hills in 1935. Pictured from left to right are Mr. G.S. Brown; Professor William Lyon Phelps; Col. S.H. Harris of West Orange, New Jersey; and Mr. C.F. Owens of New York. Also available to hotel guests were an 18-hole putting green, an 18-hole pitch and putt course, and a driving range that accommodated 16 golfers. (Courtesy Augusta Museum of History.)

PUTTING GREEN C. 1940. This postcard shows the large putting green on the west lawn of the Forest Hills-Ricker Hotel, a small part of the extensive golf facilities afforded guests of the hotel. (Courtesy Joseph M. Lee III.)

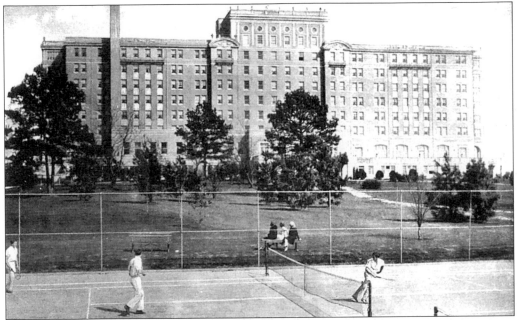

TENNIS TIME C. 1935. While golf was the focus on the front lawns of the resort, tennis courts were maintained for visitors just a short distance from the back of the Forrest Hills-Ricker Hotel. (Courtesy Joseph M. Lee III.)

IN WATROUS'S WAKE. Located to the side of the 5th green at Forest Hills, this cement marker denotes the hole where golf professional Al Watrous scored a double eagle in a Sunday practice round leading into the 1936 Masters. Watrous also scored an eagle just three holes earlier in the round and finished the day with a 65, one shot shy of the course record. (The second and fifth holes at Forest Hills were par-5s in 1936.) One day earlier, Bobby Jones established a practice round record at the Augusta National by posting eight birdies with his famous "Calamity Jane" putter, en route to a 64. Watrous played in the first Southeastern Open in 1930 and the first Masters Tournament in 1934. (Photo by Stan Byrdy; Courtesy Forest Hills Golf Club.)

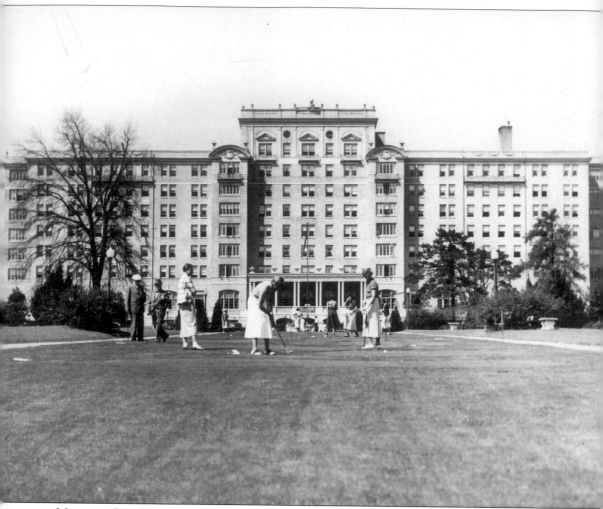

MOTHERS DAY OUT, C. 1935. Ladies sharpen their putting skills on the scotch putting greens on the front lawn of the Forrest Hills-Ricker Hotel. Golf, tennis, and horseback riding were popular sports for winter visitors. Golf was free of charge to all weekly guests. (Courtesy Augusta-Richmond County Historical Society, Reese Library, Augusta State University.)

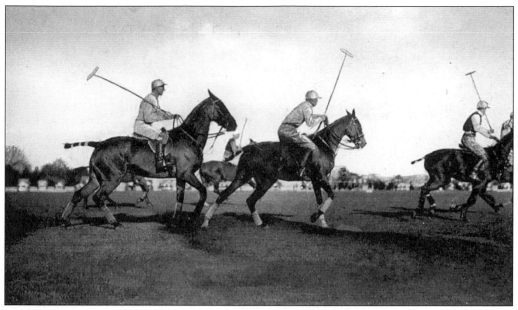

POLO POPULAR, C. 1935. The Augusta-Aiken area was billed as the winter polo center of the United States. This match is seen taking place on a field maintained at the Forrest Hills-Ricker Hotel. (Courtesy Joseph M. Lee III.)

OUT FOR A RIDE, C. 1935. Going out for a ride at the Forrest Hills-Ricker Hotel likely meant riding horses on the bridle trails, winding through pines and around the golf course. Red Price, current director at the golf club, reports finding horseshoes while digging to the side of the course's present-day second hole that runs alongside Wrightsboro Road. (Courtesy Joseph M. Lee III.)

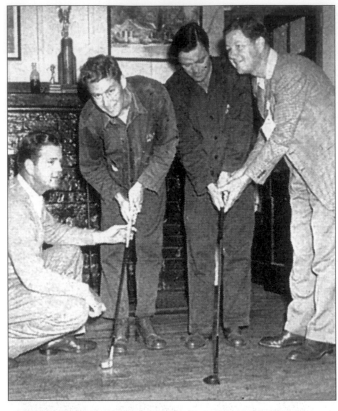

FIRESIDE CHAT, C. 1945. Masters Champions Craig Wood (left) and Byron Nelson (far right) give golf tips to patients of Oliver General Hospital. The Forest Hills-Ricker Hotel was converted into Oliver General by the U.S. Army in 1942. (Reprint from the January 1947 *Oliver Beacon*; Courtesy Ross Snellings Collection.)

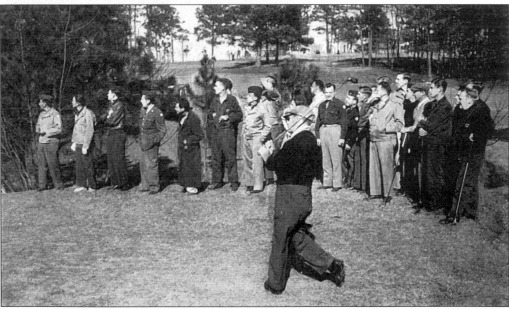

BOBBY IS BACK, C. 1946. Col. Robert Tyre Jones Jr. returns to the scene of his 1930 victory in the Southeastern Open and stages a clinic for hospital patients on the Oliver General Golf Course. Other golf greats, including Byron Nelson and Craig Wood, paid visits to the hospital during World War II. (Courtesy Joseph M. Lee III.)

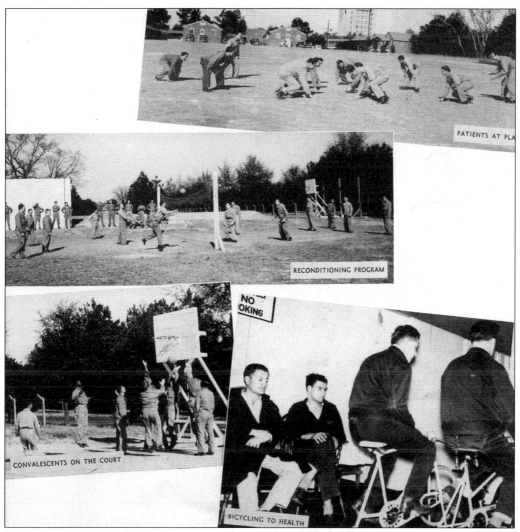

SPORTS AT OLIVER GENERAL, C. 1946. The front cover of an Oliver General Hospital brochure from the mid-1940s included the following quote: "To preserve a man alive in the midst of chances and hostilities is as great a miracle as to create him." Pictured here, patients at Oliver General Hospital in rehabilitation play football, volleyball, and basketball and ride stationary bikes. The soldiers also had access to the championship golf facility that Bobby Jones played to win the 1930 Southeastern Open. Note Oliver General Hospital (previously Forest Hills-Ricker Hotel) in the background of the top photo. (Reprint from the January 1947 *Oliver Beacon*; Courtesy Augusta Museum of History.)

OLIVER GENERAL HOSPITAL. A patient at the facility in 1949, J.M. Hale painted this priceless artwork on a piece of masonite from the front lawn of the hospital. When the building was torn down in the late 1980s, a thorough search for the painting proved futile. Years later it was uncovered in the attic of the nearby VA Hospital (previously Lenwood Hotel) and returned to Forest Hills Golf Club, where it remains on permanent display in the clubhouse dining area. (Photo by Stan Byrdy; Courtesy Forest Hills Golf Club.)

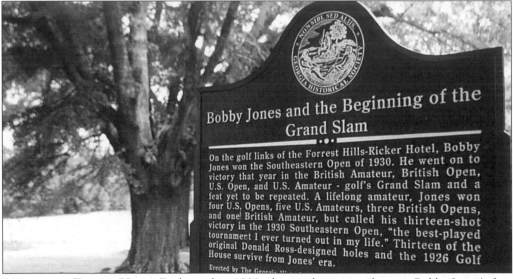

MARKER AT FOREST HILLS. Dedicated in 1999, this marker pays tribute to Bobby Jones's first win the year he won the Grand Slam. The marker reads, "On the golf links of the Forrest Hills-Ricker Hotel, Bobby Jones won the Southeastern Open of 1930. He went on to victory that year in the British Amateur, British Open, and the U.S. Amateur—golf's Grand Slam and a feat yet to be repeated. A lifelong amateur, Jones won four U.S. Opens, five U.S. Amateurs, three British Opens, and one British Amateur, but called his thirteen-shot victory in the 1930 Southeastern Open, "the best played tournament I ever turned out in my life. Thirteen of the original Donald Ross-designed holes and the 1926 Golf House survive from Jones' era." The opening to the left background of the tree is the site where the Forest Hills-Ricker Hotel once stood. (Photo by Stan Byrdy; Courtesy Forest Hills Golf Club.)

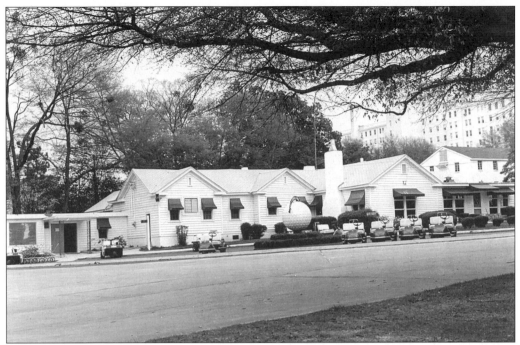

CLUBHOUSE, C. APRIL 1972. The clubhouse at Fort Gordon (Forest Hills) Golf Course is seen as it appeared in the spring of 1972. Note the VA Hospital (previously Oliver General Hospital and Ricker Hotel) in background. (Courtesy U.S. Army Photograph.)

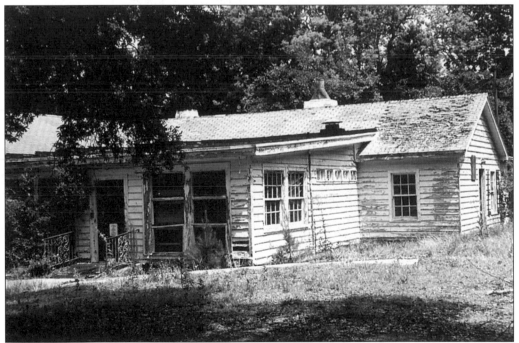

CLUBHOUSE, JULY 2002. The old clubhouse at Forest Hills stands in need of repair. An historic preservation group is hoping to raise funds to restore it, but others fear the structure may be past repair and too costly to refurbish. (Photo by Stan Byrdy; Courtesy Forest Hills Golf Club.)

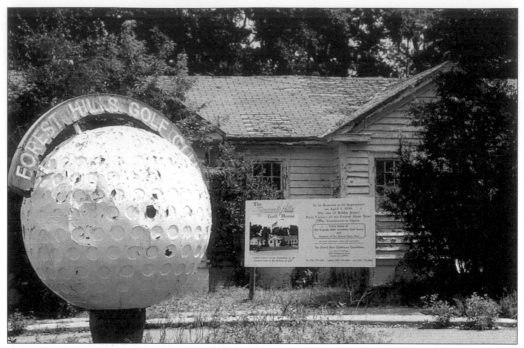

GOLF BALL AND OLD CLUBHOUSE. The distinctive golf ball in front of the old clubhouse at Forest Hills was reportedly made in a machine shop at Fort Gordon. The ball is made out of copper and contains the same number of dimples of a golf ball of its day. (Photo by Stan Byrdy; Courtesy Forest Hills Golf Club.)

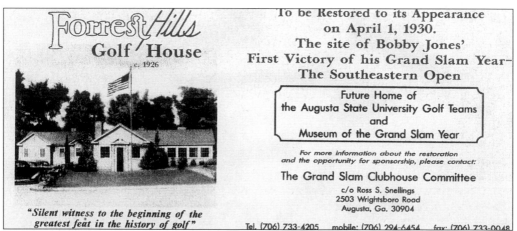

PROPOSED PLAN. The Grand Slam Clubhouse Committee headed up by Ross S. Snellings hopes to raise enough funds to restore the old clubhouse at Forest Hills to its original appearance when Bobby Jones played here in 1930. (Photo by Stan Byrdy; Courtesy Forest Hills Golf Club.)

MEDALIST MICKLESON. Phil Mickleson of Arizona State University accepts the Billy Dolan Bowl from Sam Sibley of the Augusta Golf Association as medalist in the 1989 Augusta State Invitational at Forest Hills. Mickleson's winning score of 2-over 218 for three rounds is the highest by a medalist in the 24-year history of the event. Nolan Henke, Justin Leonard, and Tim Herron are among other notables who have taken medalist honors in the ASU Invitational. (Courtesy Forest Hills Golf Club.)

VICTORY IN AUGUSTA. Phil Mickleson accepts a presentation in 1989 from Augusta State Invitational Tournament chairman Grady Smith in front of the old clubhouse at Forest Hills, which was still in use at the time. In April 1995, U.S. Amateur Champion Tiger Woods made his first start in the Masters Tournament, but not before staging a clinic for youngsters on the Forest Hills driving range. (Courtesy Forest Hills Golf Club.)

LOVE'S LOVE. Davis Love III holds the team trophy following North Carolina's winning efforts in the 1982 Forest Hills Invitational. Pictured from left to right are teammates Kelly Clair, John Hughes, coach Devon Brouse, Love, Thomas Thiele, and tournament medalist John Inman. The Tar Heels also won the event the following year, with Inman, the current coach at North Carolina, repeating as medalist. Augusta State's Roger Rowland is the only other player to win the tournament's individual title twice. (Courtesy Forest Hills Golf Club.)

JAGUAR JAUNT. Host Augusta State University has won the prestigious Forest Hills Invitational nine times in the 24-year history of the event, including four consecutive years from 1998 through 2001. ASU's Robert Duck was a member of all four teams. Pictured here left to right are Frank Mulherin, coach Jay Seawell, and ASU's winning 1999 team of Robert Duck, Oliver Wilson, Jack Doherty, Michael Webb, and tournament medalist Jamie Elson. Named in honor of Mulherin's father, the Frank X. Mulherin Jr. Cup is awarded annually to the winning team. (Courtesy Forest Hills Golf Club.)

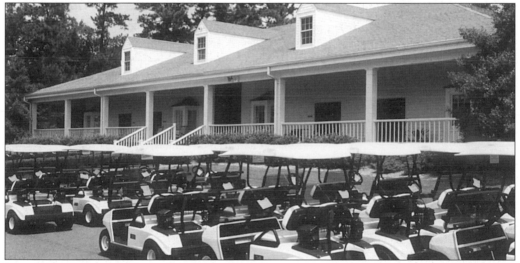

NEW CLUBHOUSE. With a new VA hospital downtown and golf course at Fort Gordon, the facilities at Forest Hills were rendered obsolete by the army in 1977. The Augusta Golf Association took up the cause of securing and then restoring the facility as home for the Augusta State University golf team. A unique operations agreement was struck in 1979, providing for the AGA to manage the course on behalf of the Augusta State Athletic Association. The gesture has paid off handsomely and today the Jaguars are among the top collegiate golf programs in the nation. The new clubhouse at Forest Hills was dedicated in 1992. The facilities at Forest Hills are home to the ASU Jaguars, who finished fifth in the nation in the 2002 NCAA Golf Championships. (Courtesy Forest Hills Golf Club.)

ONE SHARE. When Augusta's first municipal golf course was constructed in 1928, shares of capital stock were issued. Augustan Glover R. Bailey invested $10 on October 14, 1929. (Courtesy Bill Baab Collection.)

CAMP HOUSE. Shown here is Clyde Wells's depiction of the Augusta Municipal Golf Course's second clubhouse. It was originally utilized as an army barracks at Camp Hancock during World War I. Wells's *Clubhouse at the Patch* is on display in the dining room of the course's new clubhouse, which was dedicated in 1999. The course's first clubhouse was located on the opposite side of Highland Avenue from where it is today. (Artwork by Clyde Wells; Courtesy Augusta Municipal Golf Course.)

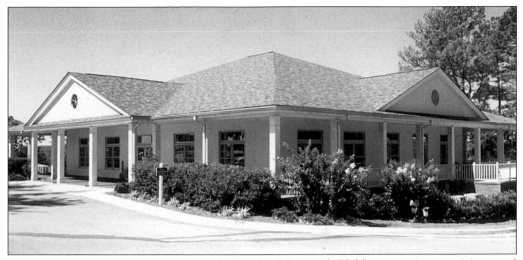

DOUGLAS'S DOMAIN. Lawson E. "Red" Douglas Memorial Clubhouse at Augusta Municipal Golf Course was officially dedicated in July 1999. Douglas served as head pro at "The Cabbage Patch" from 1946 until his death in 1991, leasing the course from the city of Augusta beginning in 1952. The course is now operated by the Recreation and Parks Department and is open year-round, with the exception of Christmas Day. Georgia Golf Hall of Fame member Jim Dent and two-time University of Georgia All-American and LPGA member Mitzi Edge are just two of the many Augustans who developed their games at the Augusta Municipal Golf Course. (Courtesy Augusta Municipal Golf Course.)

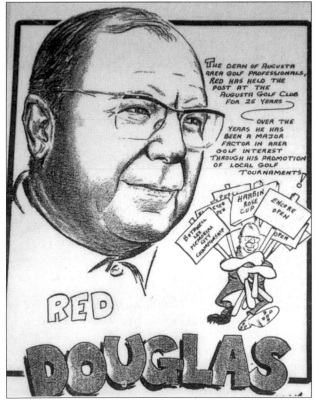

REMEMBERING RED. This caricature of Red Douglas is displayed in the new clubhouse named in his honor. The drawing was done by artist Clyde Wells for print in *The Augusta Chronicle-Herald*, in celebration of Douglas's 25th anniversary as head professional at Augusta Golf Club in 1971. (Artwork by Clyde Wells; Courtesy Augusta Municipal Golf Course.)

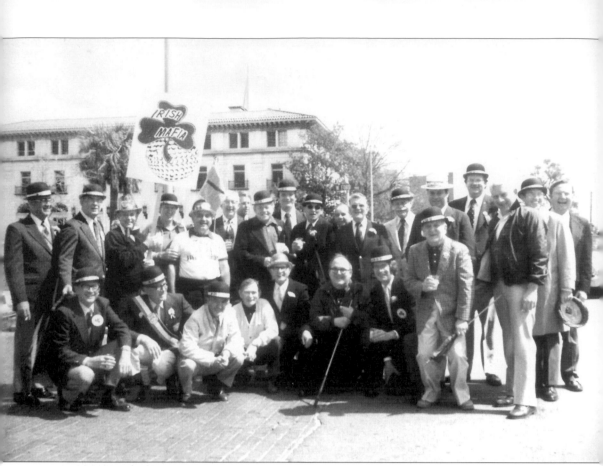

CABBAGE PATCH KIDS. When the "Irish Mafia" was formed in the early 1950s, Sam Snead and Ben Hogan were the toast of Augusta. In the half century since, the golf confraternity has grown in lore and legend, meeting each Wednesday and Saturday morning at "The Patch." A key rule in playing golf in good standing with the Irish Mafia is to "Use good judgment when moving your ball; someone may be watching." The esteemed Irish Mafia is pictured here at St. Patrick's Day festivities in 1978. (Courtesy Irish Mafia and Augusta Municipal Golf Course.)

Four

FAMOUS FACES
AND PLACES

Long before the Masters Tournament, Augusta's National Exposition of 1888 brought the nation's industrial leaders to the area and foretold of "Golf's Golden Era" in Augusta-Aiken.

Over the past century, Augusta-Aiken has hosted the prosperous and U.S. Presidents, professional golf tournaments and Major League Baseball exhibition games. Ty Cobb designated Augusta as the winter home of the Detroit Tigers, and Warren Park was considered the best minor league facility in the South. Bobby Jones took his first steps toward the impossible, then returned to build upon his dream. President Eisenhower laid the cornerstone at Reid Memorial Presbyterian Church. The photos in this chapter capture the many famous faces and places that have played a part in Augusta-Aiken's rich history.

"Golf's Golden Era" paved the way for Arnie's Army, Bears, Sharks, and Tigers. As a new century begins, unforeseen chapters wait to be written on both sides of the Savannah River, as Augusta and Aiken continue working together to build a strong foundation for future growth and opportunity.

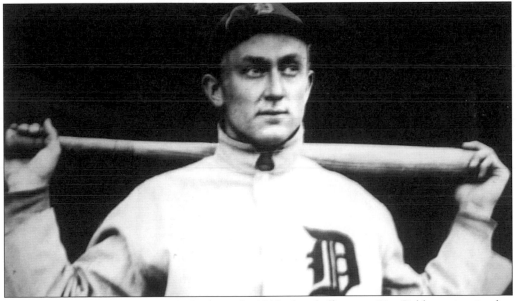

TY COBB, C. 1920. From 1910 through 1913, baseball great Ty Cobb maintained a combined .403 batting average, after which he purchased a home on William Street in Augusta's Summerville area. An avid golfer, Cobb was a member of the Augusta Country Club and won the club's 1931 Bon Air Vanderbilt Tournament. A teammate of Cobb's on the 1905 Augusta Tourists in the South Atlantic League, Nap Rucker was known as the original "Georgia Peach," a nickname that would later become synonymous with Cobb. (Courtesy Augusta Museum of History.)

FIRST AUGUSTA NATIONAL. Staged in the fall of 1888, the Augusta National Exposition was the first major event to introduce the outside world to the city. This silk ribbon was commissioned for the occasion by George R. Lombard and Company of Augusta, a foundry machine, boiler, and gin works. (Courtesy Augusta Museum of History.)

AUGUSTA EXPOSITION, C. 1888. During the fall of 1888, northern business leaders converged on this site for Augusta's National Exposition, near the present-day Gilbert-Lambuth Chapel at Paine College. The largest interior cotton port in the nation, Augusta at the time boasted a population of 40,000. Its location at the head of the Savannah River and as center for the railway system were major selling points to northern investors. Seventy-two trains arrived and departed daily in Augusta on seven railroads, with four others under construction at the time. (Courtesy Augusta Museum of History.)

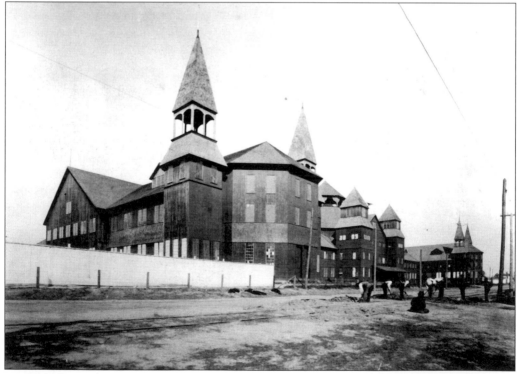

FRUITLAND FRONT, C. 1895.
Shown is the Washington Road
entrance to Fruitland Nurseries in
the late 1800s. Note the hedge-
lined front of the property, dirt-
road entrance to Magnolia Lane,
and two-lane Washington Road
in foreground. (Courtesy Augusta
Museum of History.)

FORETELLING THE FUTURE, C. 1895. Little did Fruitland Nurseries know when this envelope was mailed in the late 1800s that "Special Tees For The Trade" would one day be more appropriate. (Courtesy Bill Baab Collection.)

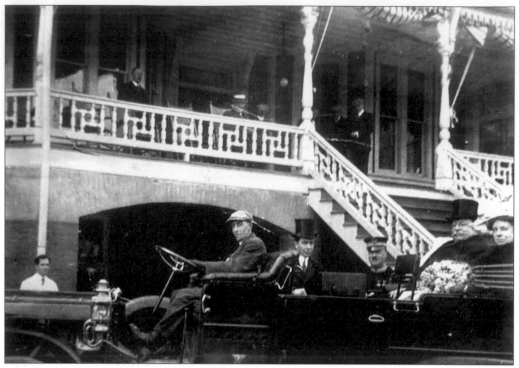

BON VOYAGE. President-elect and Mrs. William H. Taft are shown in their White Steamer automobile in front of the Bon Air Hotel prior to leaving for a barbeque at Beech Island Farmers Club on February 6, 1909. (Courtesy Beech Island Agricultural Club.)

SAND BAR TO BARBEQUE. President-elect Taft and his entourage took the Sand Bar Ferry to South Carolina, then reportedly traveled the final several miles over roads hurriedly repaired by chain gangs from Aiken and Allendale Counties. Another guest that day, John D. Rockefeller, addressed the group regarding the improvement of roads on which farmers had to travel. (Courtesy Beech Island Agricultural Club.)

BEECH ISLAND BARBEQUE. A barbeque pit is in full use in the early 1900s at the Beech Island, South Carolina Farmer's Club. (Courtesy Beech Island Agricultural Club.)

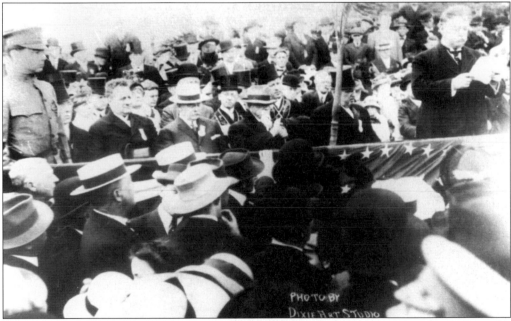

TAFT AT BUTT MEMORIAL BRIDGE, C. 1914. President William Howard Taft speaks at the dedication of the Butt Memorial Bridge in 1914, which spans the Augusta Canal at Fifteenth Street. The bridge is named in honor of Augusta native Maj. Archibald Butt, aide to Taft and President Theodore Roosevelt, who was killed on the *Titanic* while returning from an overseas Presidential assignment. Taft also attended a memorial service for Butt in Augusta two weeks after the *Titanic* sank in April 1912. (Courtesy Helen Callahan Collection, Special Collections, Reese Library, Augusta State University.)

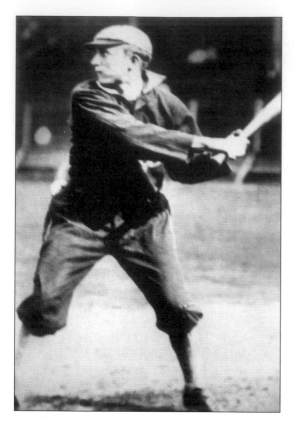

TY TERRIFIC C. 1905. A young Ty Cobb is shown here breaking into the major leagues with the Detroit Tigers. This photo is believed to have been taken during the game in which Cobb got his first base hit. From 1907 through 1913, Cobb won 12 of 13 batting titles, including nine straight between 1907 and 1915. At the height of his career, Cobb purchased a home on William Street and in the early 1920s was honorary coach of his son's baseball team at nearby Summerville School. (Courtesy Augusta Museum of History.)

PRESIDENT AT THE PARK, C. 1923. "President Sees Detroit-Toronto Game Here" read the front-page headlines in *The Augusta Chronicle* on April 4, 1923. President and Mrs. Warren G. Harding attended the preseason contest at Warren Park as guests of Baseball Commissioner Kennesaw Mountain Landis. Arriving just prior to game time, "the President took a seat on a lower row in the grandstand, asked for a scorecard, listed the line-up and got set for the game." Cobb went 2 for 4 at the plate and scored a run in the Tigers' 9-2 victory. (Courtesy Helen Callahan, Augusta-Richmond County Historical Society, Reese Library, Augusta State University.)

BRIGHT LIGHTS, BIG CITY, C. 1930. As Bobby Jones marched towards the Grand Slam, the first night game to take place south of the Mason-Dixon line was in Augusta on Saturday, July 19, 1930. Over 5,000 fans packed Municipal (Jennings) Stadium to witness a member of the Charlotte Hornets register 23 strikeouts against the Augusta Wolves, a South Atlantic League record that stands to this day. In early experiments with night baseball, lighting was reflected upward, resulting in large pools of light. Five years later, night baseball made its debut in the major leagues at Crosley Field in Cincinnati. (Courtesy Milledge G. Murray Collection.)

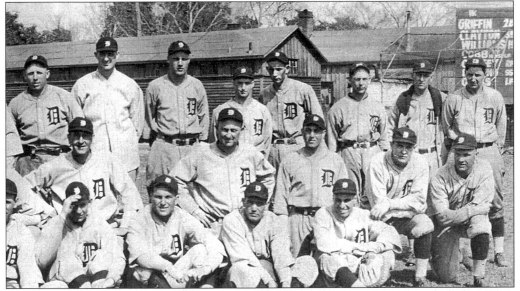

THE 1926 TIGERS. The 1926 Detroit Tigers are shown during spring training at Warren Park in 1926. Player-manager Ty Cobb kneels in the middle row, fourth from the far right. Future Hall of Famer Charley Gehringer, age 23, stands in back of Cobb, fourth player from the right. The 1926 Tigers were comprised of six players who would post .300 batting averages that season. Notice the lineup board on the far right with Cobb batting fourth and the words "Ty Himself" next to his name. Cobb arranged for installation of a drainage system at Warren Park, and St. Louis Cardinals manager Branch Rickey declared it the finest minor league baseball field in the South. (Courtesy Milledge G. Murray Collection.)

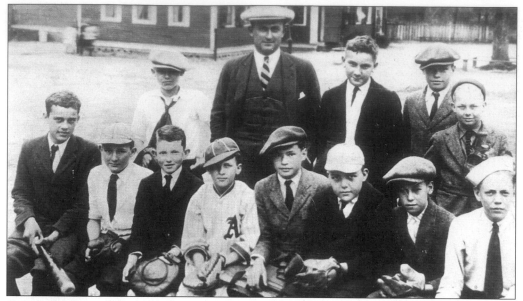

COBB'S MOB, C. 1922. The 1922 Summerville School baseball team had the advantage of having baseball great Ty Cobb as honorary coach. Ty Cobb Jr. was a member of the team, which played against other grammar schools in Augusta's "Ne-Hi League." The Cobbs owned a house on William Street, a half-block away from the present day William Robinson School. Pictured, from left to right, are (front row) Fred Green, Anson L. Clark, Jack Preacher, Billy Barrett, James Thompson, Frank E. Clark Jr., George Claussen, and Jack Dawson; (back row) W.S. Lanier, Ty Cobb, Ty Cobb Jr., Blevens Thompson, and Alley Culley. (Courtesy Douglas R. Duncan Jr. Collection.)

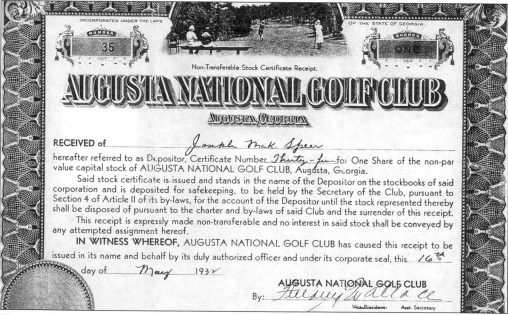

TAKING STOCK, C. 1932. This certificate was issued to Joseph Speer of McBean on May 16, 1932, nearly eight months prior to the course's official opening date. Note the scene of women playing golf in the certificate seal. (Courtesy Bill Baab Collection.)

116

TWELFTH HOLE, C. 1935. This postcard shows ladies playing golf on the 12th green at the Augusta National Golf Club. (Photo by Tony Sheehan; Courtesy Joseph M. Lee III.)

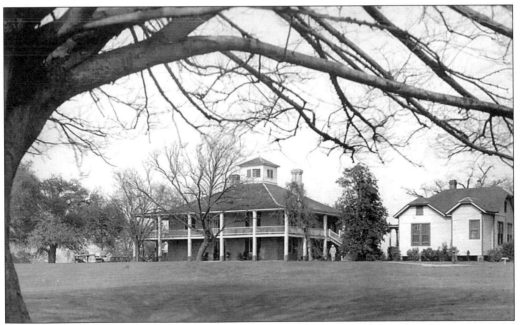

CLUBHOUSE, C. 1935. An early view of the back of the Augusta National clubhouse includes the former office building of the Fruitland Nurseries on the right. (Courtesy Joseph M. Lee III.)

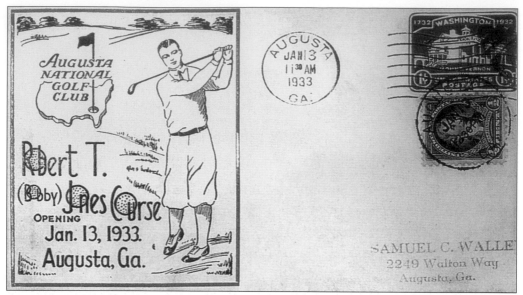

OPEN HOUSE, C. 1933. Lucky recipients found this card in their mailboxes in early 1933 announcing the official opening of the Augusta National Golf Club. This invitation was mailed to Samuel C. Waller, who resided on Walton Way in Augusta. (Courtesy Milledge G. Murray Collection.)

SECOND AND SURROUNDINGS, C. 1933. In the mid-1930s, the second hole at the Augusta National Golf Club was fronted by one bunker, a vast difference from today's sand-guarded green. Note the group of golfers and caddies on the seventh green to the far right of the photograph. (Courtesy Joseph M. Lee III.)

FOUR, C. 1935. The fourth green is shown at the Augusta National Golf Club, *c.* 1935. Note the shape of the green, the bunkers, and the sparse trees in the background. (Courtesy Joseph M. Lee III.)

SIGNATURE SETTING, C. 1935. The Augusta National Golf Club's signature par-3 12th hole is pictured as it appeared in the mid-1930s. (Courtesy Joseph M. Lee III.)

FIFTEEN GREEN, C. 1935. Gene Sarazen scored a double-eagle on this hole en route to winning the 1935 Masters. Augusta Municipal Golf Club assistant pro Hank Leffler is the only other golfer known to have posted a two on the hole. In May 1991 Leffler hit a 4-iron 195 yards to achieve the feat, finishing his round at 2-under 70. Attesting to the double-eagle were Jones Creek head pro Greg Heman, former West Lake assistant pro Chris Bottomley, and Jeff Tallman, head pro at Musgrove Mill. (Courtesy Joseph M. Lee III.)

AUGUSTA NATIONAL POSTCARD C. 1939. Postmarked September 1939, this postcard, with a picture of the Augusta National clubhouse on the front, contained the following message: "Now it can be told. It's no longer a secret why—just why—was Bobby Jones the world's greatest golfer? He collaborated with (probably was instructed by) a McKenzie [Alister MacKenzie]." (Courtesy Augusta Museum of History.)

JONES'S HOME, C. 1931. Golf great Bobby Jones surveys construction of the golf course at Augusta National Golf Club. Ironically, the Augusta National officially opened on January 13, 1933, one year to the day that Jones scored a hole-in-one at neighboring Augusta Country Club. Augusta National organizers and Augusta Country Club members Fielding Wallace and Alfred S. Bourne were in Jones's foursome the day he scored the ace. (Courtesy Augusta Museum of History.)

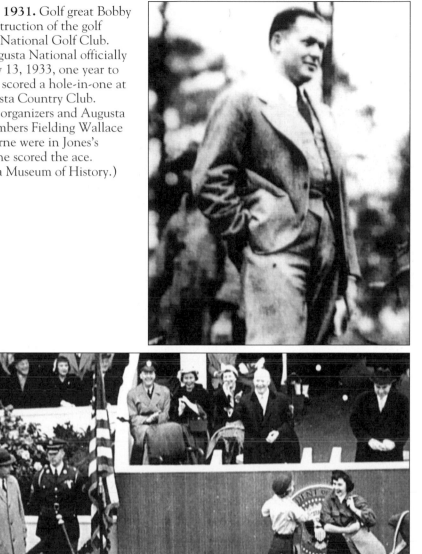

EISENHOWER INAUGURATION, C. 1953. President Eisenhower stands and waves at the Augusta golf float as it passes in front of the Presidential grandstand during inauguration ceremonies in Washington, D.C. in January, 1953. On the last of his 29 trips to Augusta as President, Eisenhower inspected the troops at Fort Gordon on Saturday, January 7th and the following morning, played one last round of golf before heading back to Washington. At 3:15 p.m. he left the grounds of the Augusta National via helicopter to Bush Field and within ten minutes, Ike was airborne for Washington. Twelve days later, John F. Kennedy was sworn in as President of the United States. (Courtesy Eisenhower Library and Augusta Museum of History.)

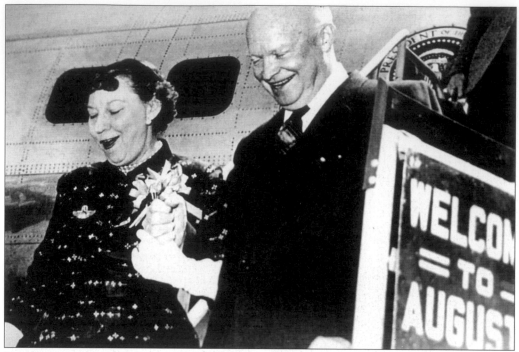

IKE ARRIVES, C. 1955. Mamie and President Dwight D. Eisenhower are all smiles as they are welcomed to Augusta for one of twenty-nine visits while Ike was in office. The first couple was housed at Mamie's Cabin on the grounds of the Augusta National, where Eisenhower played golf daily and frequently fished in the bountiful course ponds with son, David.

In 1954, Eisenhower's trip to Augusta was delayed one day due to a playoff in the Masters Tournament between Ben Hogan and Sam Snead, who eventually won. Amateur Billy Joe Patton, who nearly won the event outright, played golf with Ike on two occasions during the President's nine-day stay at the Augusta National.

During Eisenhower's nine-day vacation in April 1954, golf was on the agenda on 13 occasions, and according to Presidential Appointment Records, Ike also fished in ponds at the Augusta National a half-dozen times. During a memorable morning golf round on Saturday, April 17th, it is noted that Albert Bradley sunk a hole-in-one on the par-3 12th hole while playing in Eisenhower's foursome with Bill Robinson and Coca-Cola chief Bob Woodruff. That afternoon, Ike got in a second round of golf with Maj. John Eisenhower and two top amateurs of the day, Billy Joe Patton and Augustan Bill Zimmerman.

The following day, Easter Sunday, Ike and Mamie attended services at Reid Memorial Presbyterian Church on Walton Way at 9 a.m. The service took place in the Sunday School Auditorium, and afterwards the President laid the cornerstone for the church's new sanctuary. Then it was back to the Augusta National for an 11 a.m. tee time with the same group as the previous afternoon, Maj. John Eisenhower, Billy Joe Patton, and Augustan Bill Zimmerman. Between 3 and 5 p.m. that afternoon, Ike fished with son David. The pair also went fishing two days later between 5 and 7 p.m. at the 16th hole and according to Presidential records, hauled in several bass and bluegill. (Courtesy Eisenhower Library and Augusta Museum of History.)

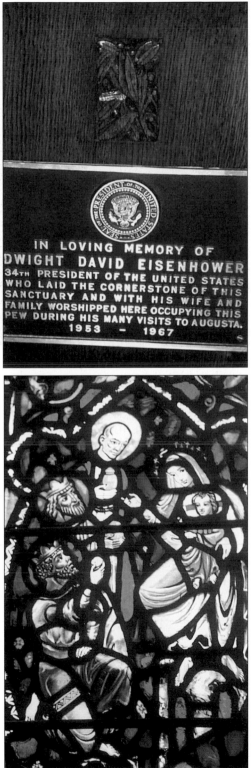

IN LOVING MEMORY OF
DWIGHT DAVID EISENHOWER
34TH PRESIDENT OF THE UNITED STATES
WHO LAID THE CORNERSTONE OF THIS
SANCTUARY AND WITH HIS WIFE AND
FAMILY WORSHIPPED HERE OCCUPYING THIS
PEW DURING HIS MANY VISITS TO AUGUSTA.
1953 — 1967

(*above*) **IKE'S PEW.** A plaque marks the sixth row pew at Reid Memorial Presbyterian Church on Walton Way, which was used by President and Mrs. Dwight Eisenhower while in Augusta during his visits to the city. This photo was taken after the pews were refinished and reinstalled as part of major renovations to the sanctuary in 2002. (Photos by Stan Byrdy; Courtesy Reid Memorial Presbyterian Church.)

(*right*) **THREE IKE'S MEN.** In this stained glass window at Reid Memorial Presbyterian, one of the three wise men bears a strong resemblance to Dwight D. Eisenhower. The President and First Lady worshiped at Reid Memorial Presbyterian Church on Walton Way during their visits to Augusta, with one exception, January 3, 1954, when they attended services at St. James Methodist Church on Greene Street. (Courtesy Reid Memorial Presbyterian Church.)

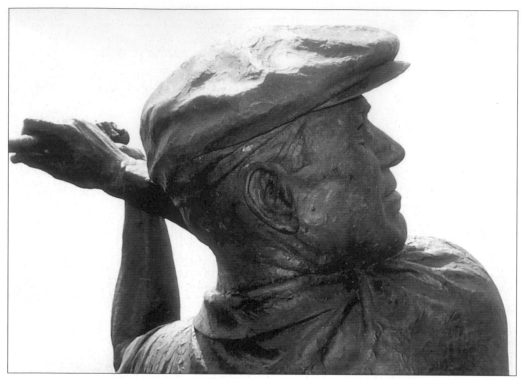

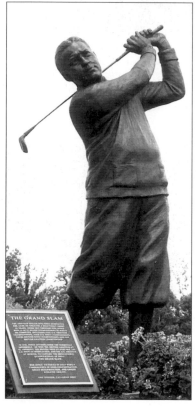

BEN HOGAN. Twice a winner of the Masters Tournament (1950 and 1953), Ben Hogan's determination and famous golf swing are captured in this bronze statue on display at the Augusta Golf and Gardens in downtown Augusta. (Photo by Stan Byrdy; Courtesy Augusta Golf and Gardens.)

BRONZE BOBBY. This replica of Bobby Jones graces the entrance to Augusta Golf and Gardens, home of the Georgia Golf Hall of Fame. Jones was enshrined in the Georgia Golf Hall of Fame with the charter class of inductees in 1989. The plaque at the base of the statue reads: "The amateur golfer Bob Jones dominated the game of golf for a relatively short 14 years. From 1923 through 1930, Jones won 13 of 21 major championships in which he competed, including five U.S. Amateur Championships, four U.S. Open Championships, three British Open Championships and one British Amateur Championship. In 1930, Jones accomplished the seemingly impossible. He won the British Amateur at St. Andrews, the British Open at Hoylake, the U.S. Open at Interlachen, and the U.S. Amateur at Merion, to capture the impregnable quadrilateral of golf, the Grand Slam. Bob Jones' victories in golf were a consequence of keen concentration, great determination and unique athletic ability." (Photo by Stan Byrdy; Courtesy Augusta Golf and Gardens.)

FIRST TEE OF AUGUSTA. Arnold Palmer is photographed at the April 2001 dedication ceremonies of The First Tee of Augusta at FORE! Augusta on Damascus Road. Located on 40 acres next to Daniel Field Airport, The First Tee of Augusta serves a membership of 850 junior golfers, in four skill levels, ages 8 to 17. Pictured on the far left is board chairman Paul Simon. Partially seen on the back row are Senator Charles Walker and Augusta Mayor Bob Young. On the far right is executive director of The First Tee, Joe Louis Barrow Jr. (Courtesy The First Tee of Augusta at FORE! Augusta.)

PUTTING ON THE RITZ. Opened in 2001 in the grand tradition of hotels that graced the Augusta-Aiken area a century ago, the 250-room Ritz-Carlton Lodge at Reynolds Plantation in Greensboro, Georgia is one of the finest inland golf resorts in the United States. On the morning of Friday, January 15, 1909, *The Augusta Chronicle* proclaimed "Atlanta To Go Wild Over Judge Taft" as the President-elect boarded a special train at Augusta's Union Station for a two-day trip to the state capital. The train stopped briefly for Taft to greet citizens in Greensboro as a grand gesture for Greene County's support in the presidential election, the only county he would pass through that provided him a majority of votes. (Courtesy Ritz-Carlton at Reynolds Plantation.)

BIBLIOGRAPHY

Augusta Chronicle, Online Archives.

Brelsford, George, Dale Haas, and Whitney Tower. *Palmetto Golf Club, The First 100 Years.* Virginia Beach, Virginia: The Donning Company Publishers, 1992.

Callahan, Helen. *A Pictorial History.* Augusta, Georgia: Augusta Richmond County Historical Society, 1998.

Cashin, Edward J. *The Story of Augusta.* Spartanburg, South Carolina: The Reprint Company, 1996.

Clark, Frank E. Jr. *Summerville Recollections.* Augusta, Georgia: 1985.

Christian, Frank. *Augusta National and the Masters, A Photgrapher's Scrapbook.* Chelsea, Michigan: Sleeping Bear Press, 1996.

Cole, Will. *The Many Faces of Aiken, A Pictorial History.* Virginia Beach, Virginia: The Donning Company Publishers, 1985.

Fields, Bill. "The Cabbage Patch." *Golf World*, April 1997.

Glenn, Rhonda. *The Illustrated History of Women's Golf.* Dallas, Texas: Taylor Publishing Company, 1991.

Greene, Vicki H., Scott W. Loehr, and Erick D. Montgomery. *An Augusta Scrapbook.* Charleston, South Carolina: Arcadia, 2000.

Huck, Charla. "Mafia Mayhem." *Augusta* Magazine. February-March 1995.

History of North Augusta, South Carolina. North Augusta Historical Society, 1980.

Nelson W. Aldrich, Jr. *Tommy Hitchcock, An American Hero.* Fleet Street Corporation, 1984.

North Augusta's 50th Anniversary 1906–1956, Historical Panorama Program, John B. Rogers Producing Company, 1956.

Roberts, Clifford. *The Story of the Augusta National Golf Club*, Doubleday and Company, Inc., 1976.

Stulb, Eileen Heffernan. *Augusta Country Club 1899-1999.* Augusta, Georgia: 1998.

WEL-COM IN. *Pictorial History of Augusta.* Augusta, Georgia: Fleming Printers, 1962.

2002 Masters Media Guide.

2002 PGA Tour Media Guide.

INDEX